THE
PHILADELPHIA
PHILLIES

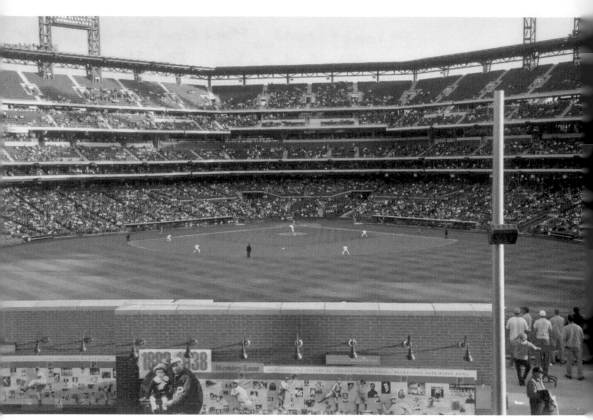

This photograph shows Citizens Bank Park, the Phillies' home field, from center field. Visible on the brick wall at the bottom of the image is a Philadelphia timeline illustrating its baseball history from 1883. In front of the brick wall is Ashburn Alley, an entertainment area named for Phillies Hall of Famer Richie Ashburn that features retail and concessions with a view of the bullpens; behind the timeline is the Phillies Wall of Fame. (National Baseball Hall of Fame Library.)

THE PHILADELPHIA PHILLIES

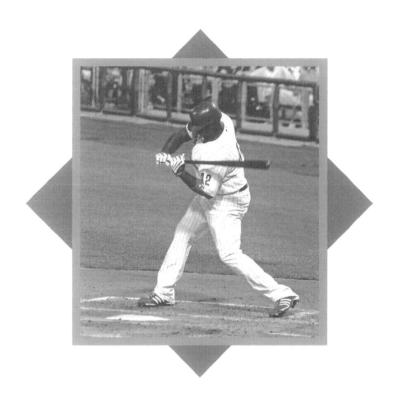

Seamus Kearney and Dick Rosen

ARCADIA
PUBLISHING

Published by Arcadia Publishing
Charleston, South Carolina

Printed in the United States of America

Library of Congress Control Number: 2010934349

For all general information, please contact Arcadia Publishing:
Telephone 843-853-2070
Fax 843-853-0044
E-mail sales@arcadiapublishing.com
For customer service and orders:
Toll-Free 1-888-313-2665

Visit us on the Internet at www.arcadiapublishing.com

To my father, Tom, a fan, and to Joan, who became a fan
 —*Seamus*

To Jeannette and to Gabriel, a future shortstop, and Uncle Dave, who
 taught me baseball history
 —*Dick*

CONTENTS

ACKNOWLEDGMENTS

A project like this one requires incredible time and effort. It cannot help being an infringement on other family members, all of whom rallied to the cause and helped make this book a reality. To Jeannette Rosen (Dick's wife), who lent her excellent organizational skills and extreme patience at a time when her other responsibilities were pressing—this could not have happened without her.

A huge thanks is due to Phillies historians and collectors of Phillies memorabilia. Among these is Bob Warrington, who provided access to his large assortment of photographs and memorabilia for our inclusion. His succinct descriptions of his holdings also made it easier to compose our captions. Also, a special thanks goes to Joe Hetrick for showing his vast collection and permitting us to use his personal photographs in the book. Likewise, Bill White supplied us his numerous Phillies photographs. It was a pleasure to visit these men and talk Phillies history. They provided much helpful information to go along with the photographs. And thanks also to David M. Jordan, chair of the Philadelphia Athletics Historical Society, for sharing some of his personal collection, as well as his knowledge of the Phillies.

A special credit goes to Freddy Berowski and Pat Kelly of the National Baseball Hall of Fame Library (NBHF) for their advice and rapid expediting of our requests.

Thanks are in order to the following: the Urban Archives Collection at Temple University Libraries (TUA) in Philadelphia, Pennsylvania, for allowing us to spend many hours perusing their vast photograph collection; the Library of Congress (LOC), for making numerous vintage photographs available through the G. G. Bain Collection as well as other collections; the Print and Picture Collection of the Free Library of Philadelphia (FLP); Ernie Montella of the Philadelphia Athletics Historical Society (PAHS), for opening their collections; Susan DiIanni of the *Philadelphia Inquirer* and *Philadelphia Daily News*, for providing us with some photographs; the George Brace Photo Collection; Larry Shenk of the Phillies, for pointing us in the right direction; Seamus Kearney, for his personal photographs; and Hal Borden, for his sage advice throughout this process.

INTRODUCTION

Philadelphia has a long baseball history with ball clubs vying for the public's attention throughout the 19th and 20th centuries. Not until the late 20th century did fan support coalesce behind a single team—the Philadelphia Phillies. Philadelphia had many teams before the Phillies came to town in 1883, including two teams called the Athletics—one in the National League (NL) that failed and another in the American Association (AA) that thrived.

Al Reach, a member of the original Athletics, came to Philadelphia in 1865 and stayed. He amassed a fortune in a sporting goods business by the 1880s and was determined to bring a NL team to Philadelphia. In 1883, he and his partner, Philadelphia lawyer Col. John Rogers, bought the defunct Worcester Ruby Legs franchise and transferred it to Philadelphia. Reach called the new team "the Phillies" because, according to him, "It's who we are and where we are."

The Phillies' first year was a disaster. Under manager Bob "Death to Flying Things" Ferguson and his successor, Blondie Purcell, the team finished dead last with 17 wins and 81 losses in their first season. But the Phillies were established, and to this day, they remain as the longest-standing team with the same name in professional sports.

Determined to make the team competitive, the Phillies' owners hired Harry Wright, a star of the 1869 Cincinnati Red Stockings and successful manager of Boston teams in the National League. Wright more than doubled the Phillies winning record (39-73) in 1884, when they finished sixth. During the next nine years, he led the Phils to finishes no lower than fourth and compiled a .500, or better, winning record in seven of those years.

The Phillies stayed competitive for the next 33 years, forming a Hall of Fame outfield in the 1890s and culminating in a NL pennant and a berth in the World Series of 1915. During this time, the Phillies built a baseball palace, the Philadelphia Baseball Park, which was their home for more than 50 years. Hailed as a marvel when it opened, it eventually became a decrepit baseball stadium hosting inferior teams.

The new ownership of William Baker, who began a period of inept and incompetent baseball management known by some historians as the "Dark Ages," is often blamed for a time in which the Phillies had only one winning record in 31 seasons. Baker took a championship team featuring Hall of Famer Grover Cleveland Alexander and turned it into mud within three years. He cared more about his money and less about the team and its fans. At the time of his death in 1930, the Phillies had experienced seven last-place finishes.

His successor, Gerry Nugent, fared no better, presiding over a team that finished in the cellar seven of his 14 seasons of ownership and near the cellar in the rest. Nugent's ownership saw the final deterioration of the baseball palace, now called Baker Bowl.

Through it all, the Phillies maintained a devoted core of followers, though far fewer than their American League (AL) rival, the Philadelphia Athletics. The "A's," as they were called, drew more fans because they were better. They won five World Series during their stay in the city from 1901 until they left in 1954.

The end of World War II brought a new beginning. Under the new ownership of the Carpenters (Robert Sr. and Bob Jr.), the Phillies hit the ground running and, by the end of the decade, had won themselves another pennant. The Phillies finally regained respectability and were now residents in Shibe Park, the park of the Athletics.

The remainder of the 1950s and the early 1960s brought little change in the up-and-down Phillies. The Phils almost scored a winning year in 1964, but the team had to wait until the late 1970s to be in contention. In those years, there were many "almosts." Gradually, the "Fightin' Phils" worked their way to another pennant in 1980 and won the first World Series in their history.

They returned to the World Series in 1983 and 1993, but again, the Phillies found themselves falling short. It would take another 15 years for the Phillies to build a team strong enough to contend every year.

With a World Series win in 2008 and nearly another in 2009, a strong fan base, and an excellent front office, the Phillies should be at, or near, the top for years to come.

THE WORLD SERIES

During the 128 seasons of their existence, the Philadelphia Phillies have won two World Series and seven NL pennants. Both World Series victories were special. The 1980 win broke a drought of 98 years, and 2008 brought Philadelphia its first major sports championship in 25 years.

The first two of their NL pennants produced only one total win in the World Series; in 1915, they lost to the Red Sox, four games to one, and in 1950, they were swept by the Yankees.

Three decades later, the 1980 Phillies again finished atop the National League. After beating Montreal on the next to last day of the season, they went on to best the Houston Astros in a five-game National League Championship Series (NLCS). Their AL opponent in the World Series was the Kansas City Royals, who fell to the Phils in a six-game series. The Phillies could now boast a World Series Championship.

In 1983, and again in 1993, the Phillies found themselves in the World Series. After winning Game 1 in 1983, they dropped four straight to the Baltimore Orioles. In 1993, the Phillies would fall victim to the Toronto Blue Jays, who finally won in the sixth game on a Joe Carter walk-off homer.

Fifteen years later, under the guidance of manager Charlie Manuel, the 2008 Phillies finished first in the NL East. In the National League Division Series (NLDS), they beat the Brewers in three of four games and then took the Dodgers four games to one in the NLCS. Against the Tampa Bay Rays, the Phillies prevailed four games to one in the World Series. For the second time in their history, the Phillies had won it all.

A year later, the Phillies won their first ever back-to-back NL pennants. Their opponent, the New York Yankees, bested them in a six-game series. For the first time, Phillies fans could cry out, "Wait till next year!" and really mean it.

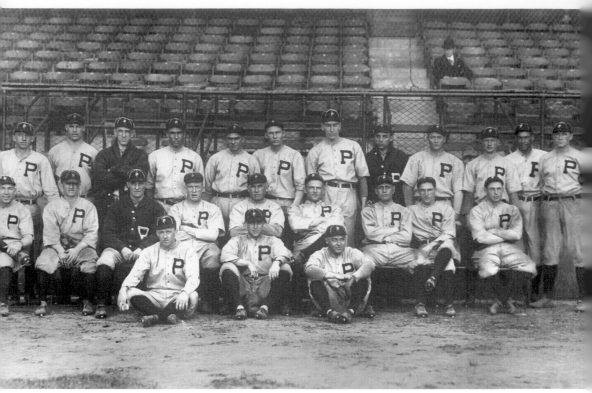

After 33 years in the league, the Phillies finally won their first NL pennant in 1915. The Phils led most of the season and finished seven games ahead of the second-place Brooklyn Robins. While possessing a team batting average of .247 (fifth in the NL), they were second in runs scored and second in on-base percentage (OBP). Additionally, they led the National League with 58 home runs, 35 of them hit by Gavvy Cravath and Beals Becker. Their pitching was strong, leading the league in ERA, strikeouts, and shutouts. Their five-man rotation won 85 of their 90 wins. They met the favored AL champions, the Boston Red Sox, in the World Series but disappointed their followers as they took the first game but lost the next four. (Bob Warrington.)

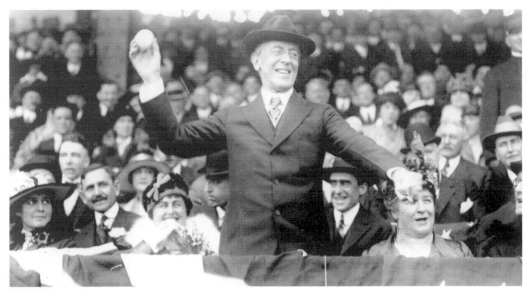

The Phillies achieved another first in 1915 when Pres. Woodrow Wilson became the first sitting U.S. president to attend a World Series and throw out the first ball in Game 2. Unfortunately, the Phillies could not capitalize on Wilson's appearance, as the Red Sox broke a 1-1 tie with a single run in the top of the ninth to win the game. In this photograph, President Wilson tosses the ball in Washington, D.C., on opening day in 1916. (LOC.)

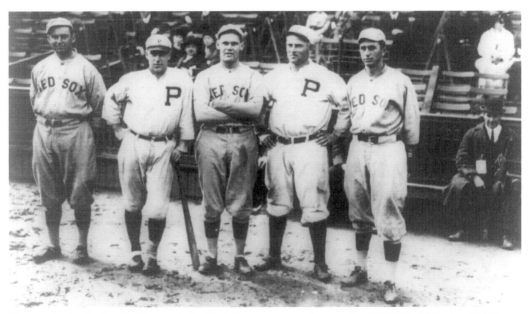

Players for both the Phillies and the Red Sox pose together at the 1915 World Series. Ed Burns (second from left) played as backup catcher to regular Bill Killefer, but he played the whole Series because Killefer suffered an injury to his throwing shoulder in early September. Burns contributed little to the Phillies effort during the Series. Harry Hooper (far right) of the Red Sox hit two home runs in the Series, including the final game's clincher in the top of the ninth inning. (LOC.)

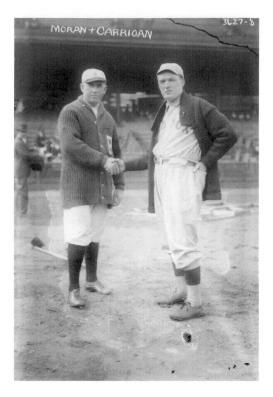

At left, skippers Pat Moran of the Phillies and Bill "Rough" Carrigan of the Boston Red Sox greet each other before the start of the 1915 World Series. The Red Sox got the better of the Phillies, winning four games to one. As both men were catchers, they must have admired the pitching performances. All five games were pitching duels, with three of them decided in the ninth inning. Rube Foster (Red Sox) won two games, while Ernie Shore (Red Sox) and Grover Cleveland Alexander (Phils) each went 1-1. The Phils' best hitter, Gavvy Cravath, was limited to a .125 batting average; the team batted only .182. Below, Carrigan presents a huge loving cup to Moran before the first game of the Series. The cup was a token of appreciation offered to Moran by the Phillies players for the first ever NL pennant in Philadelphia. (Both, LOC.)

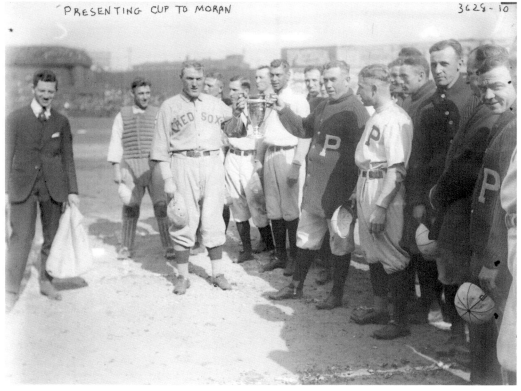

Red Sox pitcher Ernie Shore shakes hands with Grover Cleveland Alexander at the 1915 World Series. Each pitcher won and lost one game, with Alexander defeating Shore in Game 1. Four of the five games were one-run victories by the Red Sox, and three of those were captured when the Red Sox scored single runs during their respective ninth- inning at-bats. (LOC.)

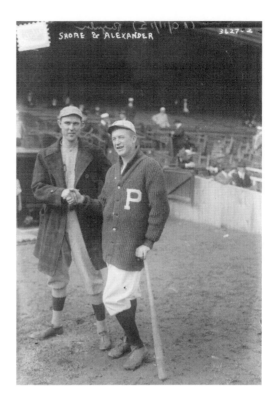

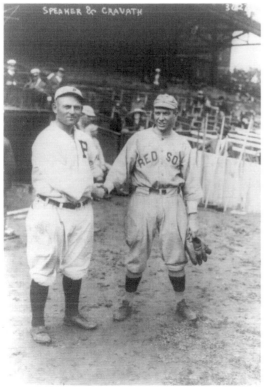

Phillies slugger "Gavvy" Cravath greets Red Sox outfielder Tris Speaker before the Series. Cravath could not produce, batting poorly and striking out six times. Speaker fared a little better, but the Series turned because the Red Sox outfield contributed mightily to their team's victories, collectively batting .363 with three home runs and eight RBI. (LOC.)

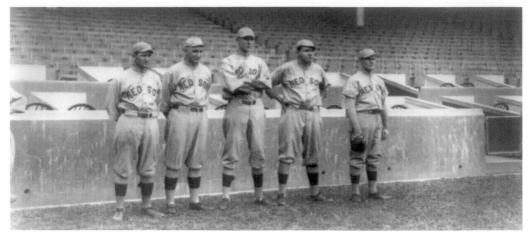

The Phillies' opponents in the Series pose with their starting rotation during the season. This quintet of, from left to right, Rube Foster, Carl Mays, Ernie Shore, Babe Ruth, and Dutch Leonard won 77 games in 1915. Missing is "Smokey Joe" Wood, who went 15-5 and led the American League with a 1.49 ERA. Also on this team was future Phillies general manager Herb Pennock. (LOC.)

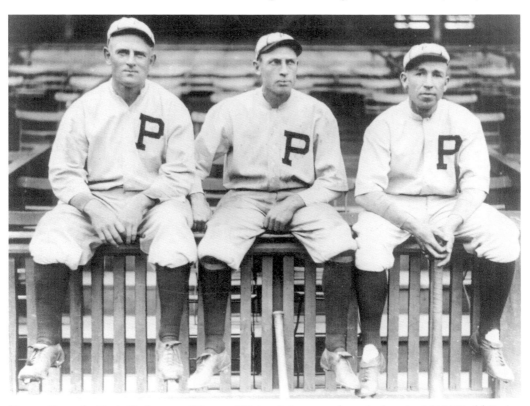

Gavvy Cravath, Dode Paskert, and Possum Whitted sit atop a fence before the 1915 World Series, the first for the Phillies. During the season, Cravath hit a monster 24 home runs along with 115 RBI and led the National League in outfield assists with 28. Defensive marvel Paskert teamed with Beals Becker in center field, and Whitted achieved his third-highest career batting average. (NBHF.)

At right is an invitation to the testimonial banquet held at Philadelphia's Bellevue-Stratford Hotel in October 1915. While the Phillies had lost to the Red Sox in the World Series, they were still honored by this formal dinner at the luxurious hotel. (Bob Warrington.)

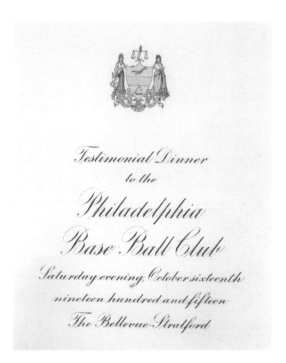

Testimonial Dinner
to the

Philadelphia
Base Ball Club

Saturday evening, October sixteenth
nineteen hundred and fifteen
The Bellevue-Stratford

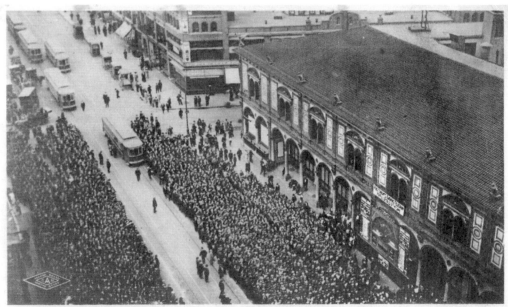

世界選手權試合の經過を見んとして紐育ブロード街イブニングテレグラム新聞社自働揭示板
前に殺到せる群衆の一部

This postcard, intended for mailing to Japan from the 1915 World Series, shows a crowd outside the *Philadelphia Telegraph* newspaper office. Major newspapers often had large baseball diamonds and scoreboards on the front of their buildings to give crowds updates of game developments—received via telegraph—so people could follow the action. Baseball had really taken off in Japan by 1915, so Japanese-language postcards were manufactured to send there. (Bob Warrington.)

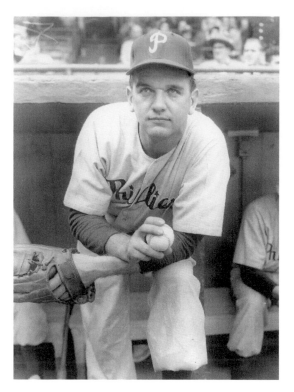

In 1950, Jim Konstanty was key to the Phillies' run for the pennant and was awarded the National League MVP in 1950. When Curt Simmons was called into active service during the Korean War and was not able to pitch in the World Series, manager Eddie Sawyer tapped Konstanty to start the first game. He responded brilliantly, allowing only one run in eight innings; however, the Phillies could not score on Vic Raschi and ultimately lost the game. (NBHF.)

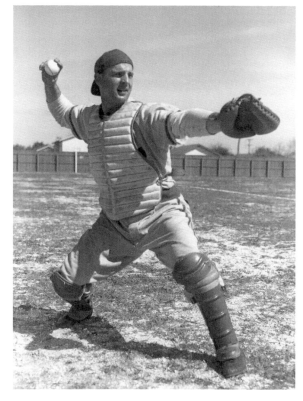

A slow-footed, slow-developing but determined catcher, Andy Seminick blossomed as the "Whiz Kids" matured. The Whiz Kids were young players who emerged after World War II to give the Phillies a strong core. In 1950, they were the youngest team (average age 26) to ever win a pennant. Seminick proved a steadying influence behind the plate to the crop of young pitchers in the late 1940s. He was also tough—he played the 1950 World Series behind the plate with a broken ankle. In two stints with the Phils, he hit 123 home runs. (NBHF.)

THE WORLD SERIES

Awaiting the beginning of the 1950 World Series, Eddie Waitkus, first baseman, poses with the legendary Joe DiMaggio. DiMaggio, in his ninth World Series, would help lead the Yankees to a four-game sweep of the Whiz Kids. Waitkus, who had recovered from gunshot wounds inflicted by a crazed stalker in a Chicago hotel in 1949, came back to help the Phillies win their first NL pennant since 1915. (NBHF.)

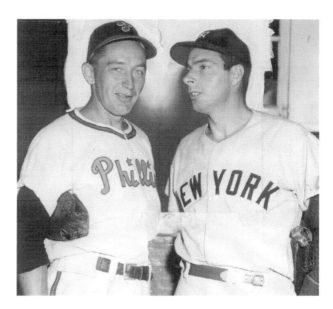

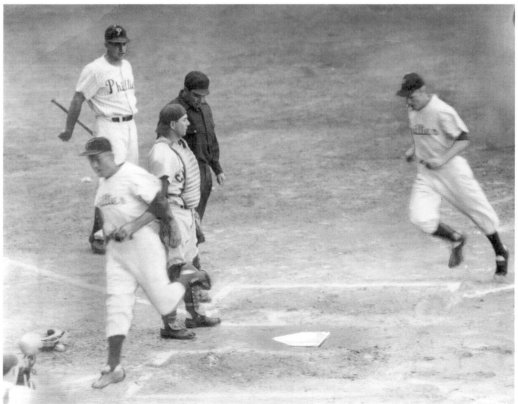

On July 25, 1950, Dick Sisler doubled to send two runs scampering home during the Phillies' run for the pennant. Here Eddie Waitkus crosses the plate as Richie Ashburn follows closely on his heels. Del Ennis awaits his at-bat. This scene portends Sisler's three-run homer in the 10th inning of the final game of the season, to give the Phils the NL pennant. (TUA.)

THE PHILADELPHIA PHILLIES

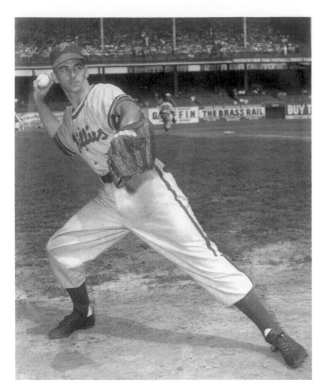

First signed as a 17-year-old by Herb Pennock's scouts in 1944, Granny Hamner emerged in 1949 as the regular shortstop for the Whiz Kids. He led the Phillies in the 1950 World Series with a .429 batting average. He became the first all-star to start at two different positions—shortstop in 1952 and second base in 1954. (NBHF.)

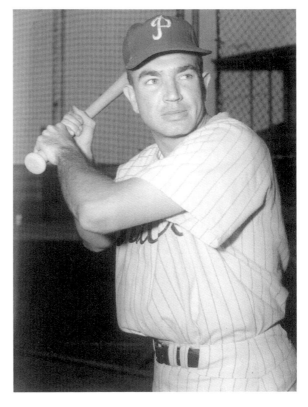

Willie Jones played third base for the Whiz Kids and the Phillies for 11 seasons. Along with Hamner, he played well during the Series and batted .286. He led the National League in putouts seven times and ranks 10th in the majors for career putouts. His nickname, "Puddin' Head" (probably derived from a Mark Twain character), is considered the best in Phillies history. (NBHF.)

Left fielder Del Ennis hit 31 home runs and led the National League in RBI for the 1950 Whiz Kids as he helped capture the Phillies' second NL pennant. He led the team in batting average and home runs and, along with Seminick's 24 home runs and Jones's 25, provided the power for the NL champions. Unfortunately, he could not carry this success into the Series, batting only .143. (NBHF.)

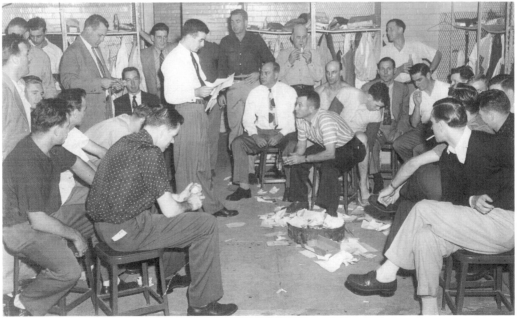

Granny Hamner, Phillies shortstop and players' representative, conducts a team meeting in the locker room before the start of the 1950 World Series. The team is deciding how to split World Series money among the players. Unfortunately, two days later, the Phillies would begin a Series in which they were unable to win a single game. The losers' share for the Phillies was $4,081, and the Yankees' share was $5,737. (LaRue/*Philadelphia Inquirer*.)

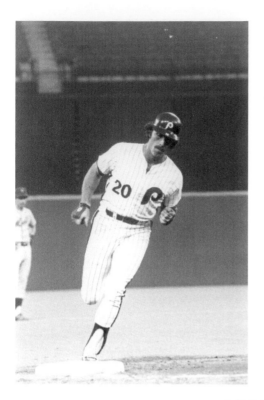

Mike Schmidt batted his Phillies into the 1980 World Series with a league-leading 48 home runs and 121 RBI while capturing another Gold Glove. In the Series he batted .381 with two home runs and seven RBI, leading the Phillies to victory. He was named the MVP for the Series, an honor he well earned. (NBHF.)

In 1980, Steve Carlton led his team with 24 victories and the National League with 286 strikeouts in a league-leading 304 innings pitched. He was perfect in the postseason, with a 3-0 record against the Houston Astros in the NLCS and the Kansas City Royals in the World Series. He won Games 1 and 6 in the Series, compiling a 2.41 ERA against the Royals. (NBHF.)

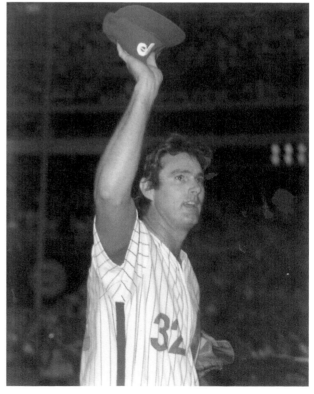

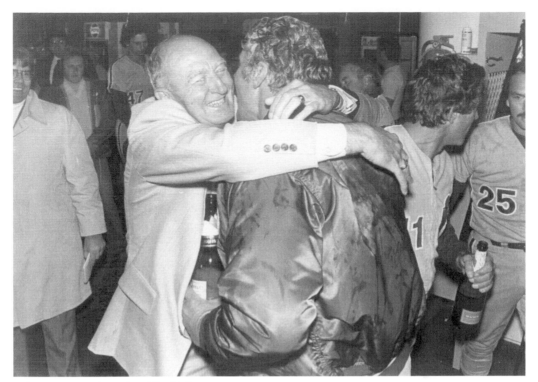

After winning their first World Series, Phillies general manager Paul Owens (left) hugs field manager Dallas Green in the locker room. Owens was general manager for two NL pennants, in 1980 and 1983. His stint as general manager of the Phillies began in June 1972 and lasted through 1984. Twice in that period, Owens added the title of field manager to his duties. In 1983, he assumed the uniformed managerial role midseason, leading the Phils to their fourth pennant. (*Philadelphia Daily News.*)

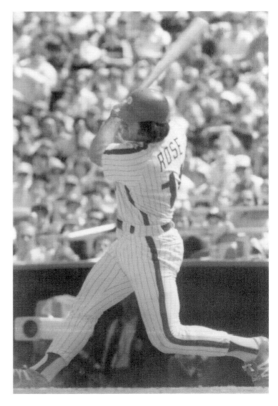

Already possessing two World Series rings with the Reds, Pete Rose came to the Phillies as a free agent in 1979 and added another ring with the 1980 Phillies. Every Phillies fan the world over saw him as a savior when he caught Bob Boone's errant catch in the ninth inning of the last game of the Series. As a Phillie in 1983, he broke Stan Musial's NL career hits record. (NBHF.)

Greg Luzinski, "the Bull," was the Phillies' regular left fielder from 1970 to 1980. Luzinski led the league in RBI (120) in 1975 and finished second to Joe Morgan in MVP voting that year. He was a NL all-star four times. Despite his batting success, he went hitless in the Series, but his power was not needed, as the Phils won. (NBHF.)

Dubbed "the Secretary of Defense," Garry Maddox won eight Gold Gloves while with the Phillies. Only Willie Mays, Roberto Clemente, and Andruw Jones have won more as NL outfielders. It has been said (probably by Harry Kalas), "Two-thirds of the Earth is covered by water, the other third by Garry Maddox." Maddox hit over .300 in 1976 for the Phillies, and he was instrumental in the Phillies' 1980 and 1983 World Series appearances. (NBHF.)

Frank Edwin "Tug" McGraw pitched in the National League for 19 years, 10 of them with the Phillies. His best pitch was the screwball, a term which was often used to describe the man himself. By the end of the 1980 postseason, McGraw had perfected this patented leap for joy. Each time he was on the mound for the last strike out, "the Tugger" seemed to repeat this pose. In the NLCS, McGraw recorded two saves against the Houston Astros. In the World Series, he matched his save total. During that World Series versus the Kansas City Royals, he struck out Willie Wilson to end the first game and again to end the sixth (and final) game as the Phils won the Series, four games to two. In a recent poll among Philadelphia sports fans, this image was voted the most famous in Philadelphia sports history. (*Philadelphia Inquirer*.)

THE PHILADELPHIA PHILLIES

In Game 1 of the 1983 World Series, the Phillies beat the Baltimore Orioles, 2-1. All three runs were scored on solo homers. Jim Dwyer hit one for the "O's," while Joe Morgan and Garry Maddox each hit one for the Phillies. Here the Phillies are celebrating this victory, but it would be their last of that Series, as the Orioles won in five games. (Tom Gralish/*Philadelphia Inquirer*.)

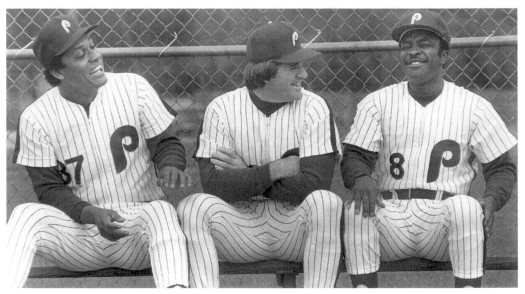

"The Big Red Machine" makes its final stop in Philadelphia in 1983. Former Cincinnati players, from left to right, Tony Perez, Pete Rose, and Joe Morgan were reunited as Phillies in 1983. The 1983 team, affectionately known as the "Wheeze Kids," a comic throwback to the 1950 Whiz Kids, had many senior players but still managed to eke out a NL pennant. They beat the Dodgers in the NLCS, but were unable to beat the younger Orioles in the World Series. (George Reynolds/*Philadelphia Daily News*.)

In 1993, the Phillies got into the World Series largely on the arm of lefty Mitch Williams, their closer. Williams had recorded 43 saves during the regular season and two more against the Braves in the NLCS (he was also the winning pitcher in the other two Phillies wins in that series). This photograph shows his leap for joy as the Phils clinch the win to punch their ticket to the World Series. (George Reynolds/*Philadelphia Daily News*.)

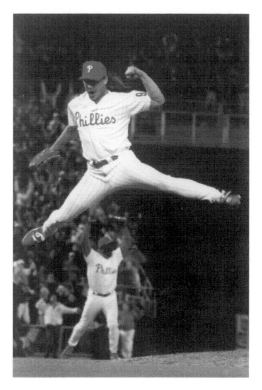

In Game 5 of the NLCS, Len Dykstra, Phillies center fielder, hits a game-winning homer in the top of the 10th inning at Atlanta–Fulton County Stadium. The Phillies defeated the Braves four games to two and won the right to meet the reigning champion, the Toronto Blue Jays, in the World Series. The Phillies lost to the Blue Jays four games to two in that World Series, as Joe Carter had a walk-off home run in Game 6. (*Philadelphia Inquirer* Archive.)

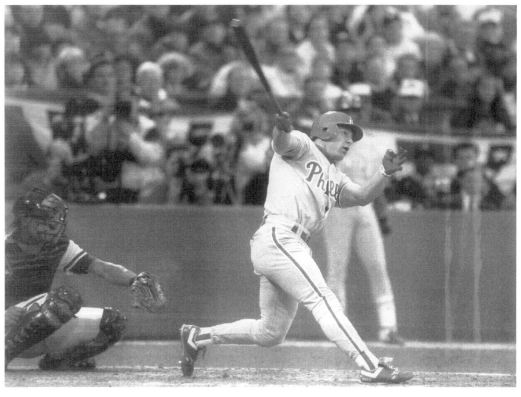

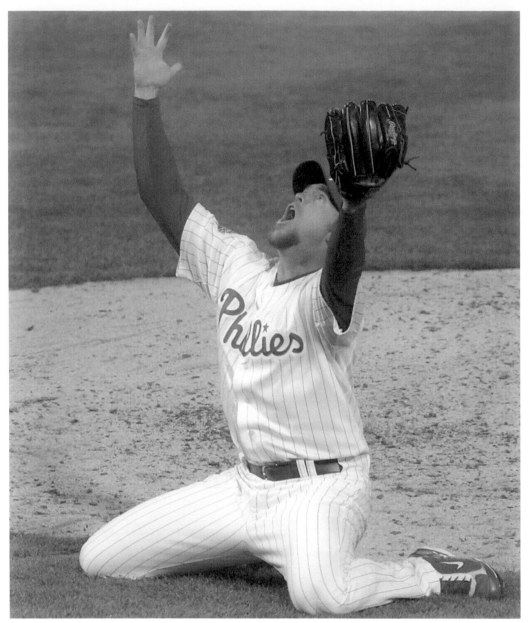

After another 15 years, the Phillies earned their way back to the World Series. In this photograph, Brad Lidge, Phillies closer, is seen in a jubilant pose at the end of Game 5. Lidge, who had 41 saves in as many opportunities during the regular season, recorded two saves in the NLDS, three in the NLCS, and two more in the World Series. This game took three days to complete (October 27 to October 29) because of several days of hurricane-like weather. At the end of the first day, the score was tied, and when play resumed, the Phillies scored the winning run in the eighth inning. Lidge assumed this pose after he struck out Eric Hinske of the Tampa Bay Rays to win the Series, four games to one. This marked the second World Series championship for the "Fightins." (David Maialetti/*Philadelphia Daily News*.)

THEY PLAYED THE GAME

In 2007, when the Philadelphia Phillies recorded their 10,000th loss, many loyal fans were forced to grin and bear it through the taunting that often goes on in Philadelphia professional sports. It is often too easy to mock Philadelphia baseball since there seems to be so many negative statistics associated with it. Terrible records for years and a series of bad trades often crippled a team that was on the verge of something special. Even the Philadelphia Athletics, who saw much more success in the early 1910s and late 1920s, faced the disintegration of excellent teams by an owner who found it difficult to cope with the financial pressures of the time. But, through all this turmoil and disappointment, there were fans who remained loyal, even when the Phillies' AL counterparts (playing only five blocks away or, later, in the same ballpark) were treating their fans to several years of success. To appreciate the Phillies historically, however, one must look to the strength of the athletes who played with them. Many performed with greatness in Philadelphia but were unrewarded because of the inferior teams they played with, causing them to suffer through many years of second-division, if not last-place, standings. There are many shining stars, several of whom were destined for the Baseball Hall of Fame, even after their time with the Phillies.

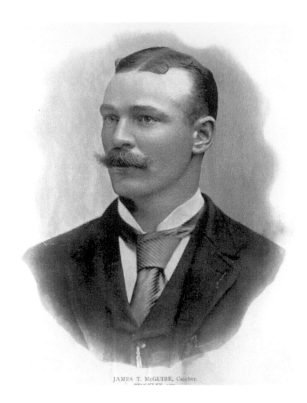

JAMES T. McGUIRE, Catcher,
BROOKLYN 1897

James Thomas "Deacon" McGuire spent 26 seasons in the majors, mainly as a catcher. He also managed for seven years and served as a substitute umpire during four seasons. By being forced into service at age 49 in the 1912 game in which Ty Cobb was suspended, McGuire played in his 26th year, establishing a record that lasted until Nolan Ryan surpassed it in 1993. McGuire played for 12 different teams in the National League (three years with the Phillies), the American Association, and the American League. (NBHF.)

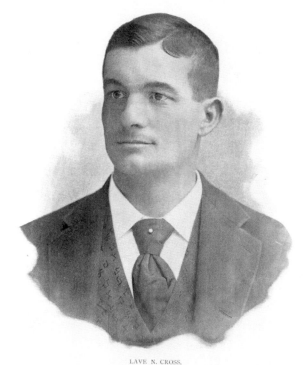

LAVE N. CROSS,
THIRD BASEMAN, ST. LOUIS, 1899.

Lave Cross was a catcher and second baseman for both the Phillies and A's. In fact, he played for four teams in Philly during his long career. With the Phillies, his 15 assists at second base on August 5, 1897, lasted 85 years as a major-league record. With the A's, he played 447 consecutive games and, in 1902, achieved 108 RBI without hitting a single home run. (NBHF.)

THEY PLAYED THE GAME

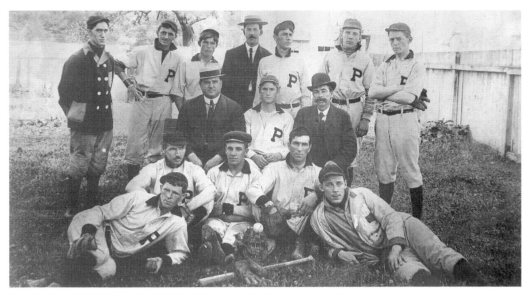

In what may be the earliest photograph of Phillies spring training, the team is shown in Charlotte, North Carolina, in 1900. Some players are wearing the 1899 Phillies uniform, but overall, dress seems to be casual. Those in civilian attire may include the business manager (second row, left), whose job it was to dole out the players' per diem and keep costs to a minimum, and the athletic trainer (second row, right). (Bob Warrington.)

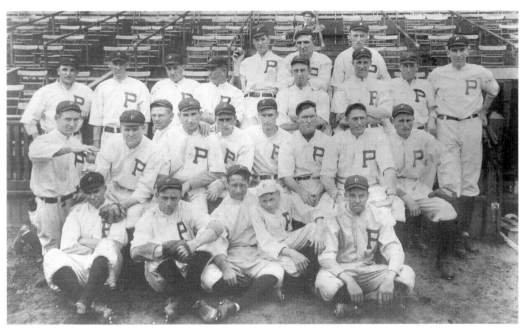

The informality of the 1913 Phillies team is apparent in this photograph, with Bill Killefer (first row, far left) having two baseballs held over his head as the picture was taken—not quite the decorum of a contemporary team picture. After a very competitive first half of the season, the 1913 Phillies finished in second place to the New York Giants. (Bob Warrington.)

A late bloomer, Gavvy Cravath arrived in 1912 at the age of 31. He quickly established his power by leading the league in home runs six times in the pre–Babe Ruth era, averaging 15.6 homers a year. Cravath became the manager of the Phillies in 1919 and 1920. (Bob Warrington.)

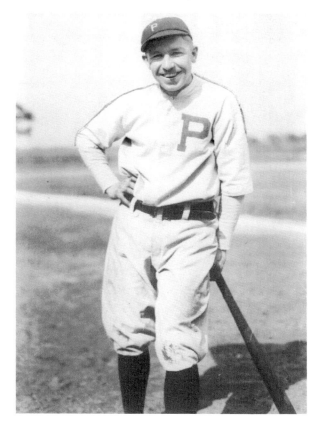

Outfielder George "Possum" Whitted played 11 seasons in the major leagues. He arrived in Philadelphia when he was traded from the Braves for Sherry Magee in 1914. Whitted hit .281 that year and continued at that level for three years. He was traded to the Pirates in 1919 and retired in 1922. He went on to coach at Duke University. (Bob Warrington.)

THEY PLAYED THE GAME

George "Dode" Paskert spent 15 seasons in the major leagues. He was an excellent defensive center fielder and hit as high as .315 in 1912. Paskert's performance dropped off in the late 1910s, so he was traded to the Cubs in what may have been the Phillies' second-best trade in history. In return for Paskert, the Phils got Cy Williams, a shining star for the Phillies throughout the 1920s. (Bob Warrington.)

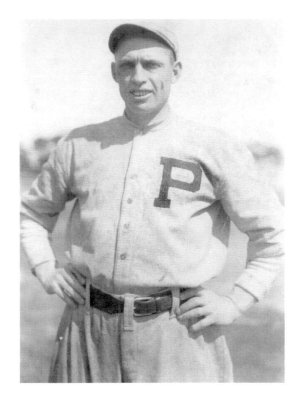

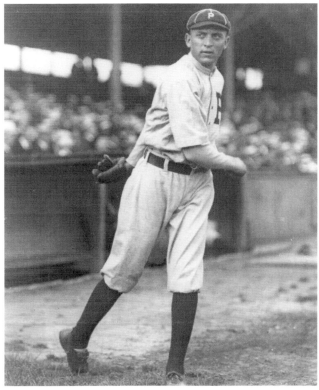

Erskine Mayer was the Phillies' second starter behind Grover Cleveland Alexander in the pennant-winning 1915 team. He won 21 games that year to match his 1914 wins total. Despite a fine pitching effort, Mayer lost two games in the World Series against the Red Sox. His ascent to greatness was swift, and just as quickly, he hit rock bottom. (NBHF.)

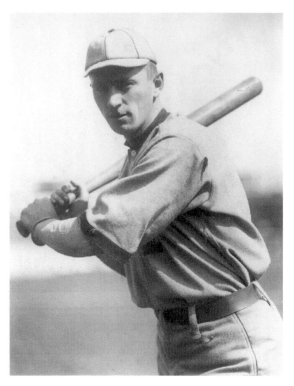

Sherry Magee spent 11 successful years (1904–1914) with the Phillies. His best year was 1910, when he won the NL batting title (.331, 123 RBI). But Magee had a terrible reputation with umpires. In 1911, while in the middle of a successful season, Magee was called out on a third strike that appeared to be a bit high. After being ejected, Magee punched umpire Bill Finneran and bloodied his face. Magee was suspended for the remainder of the season. At the end of the 1914 season, Magee was traded to the Braves for Possum Whitted and missed a trip to the World Series. Ironically, Magee eventually became a NL umpire and was praised for his coolness and fairness. (Both, NBHF.)

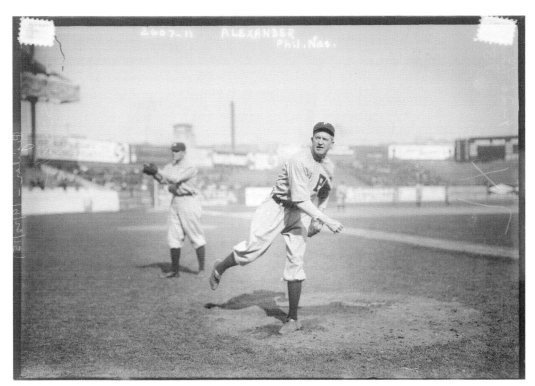

Grover Cleveland Alexander, also known as "Old Pete," was one of the greatest pitchers in baseball history. As a rookie, he was almost sent back to the minors because of wildness, but he was straightened out by catcher Pat Moran and manager Charles Dooin. He went on to win 28 games in his inaugural season, the most in the National League that year. Starring with the Phils from 1911 to 1917, he won 190 games. (Bob Warrington.)

Dave Bancroft came to the Phillies in 1915, just in time to play in the World Series. "Beauty" Bancroft was a slick fielding shortstop that could hit as well. He hit over .300 five times, but only after he was traded to the New York Giants and then to the Boston Braves. He managed the Braves from 1924 to 1927 and then managed in the All-American Girls Professional Baseball League. He was elected to the Hall of Fame in 1971. (NBHF.)

THE PHILADELPHIA PHILLIES

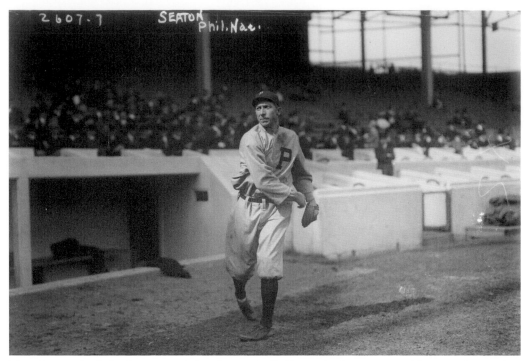

Tom Seaton had the best record for the 1913 Phillies, which is remarkable considering that his teammate was Grover Cleveland Alexander. Seaton led the league in wins, strikeouts, and innings pitched. He did not sign with the Phils in 1914 because his wife, Rene, blamed the Phillies for the death of their son during childbirth. Because the Phillies forced Seaton to pitch in his regular turn, he was unable to be at her bedside. Instead, at Rene's insistence, he accepted a lucrative offer from the Federal League's Brooklyn Tip-Tops. (LOC.)

Stan Baumgartner came to the Phillies in 1914 as a 19-year-old pitcher. He was with the Phillies intermittently from 1914 to 1922. His best year in the majors was with the Philadelphia Athletics in 1924. After retiring, Baumgartner remained in Philadelphia as a sports reporter for the *Sporting News* and the *Philadelphia Inquirer*. He supplemented his earnings by refereeing wrestling matches at the old Philadelphia Arena. (NBHF.)

THEY PLAYED THE GAME

Ed Abbatichio, "Batty," was one of the first Italian American players in baseball. He started his nine-year career with the Phillies in 1897, playing mostly shortstop and second base. By 1909, he was with the Pittsburgh Pirates, teaming with Honus Wagner as the double-play combo. He batted once in the World Series that year but struck out. He played professional football in the Pittsburgh area and may be responsible for developing the first spiral punt. (LOC.)

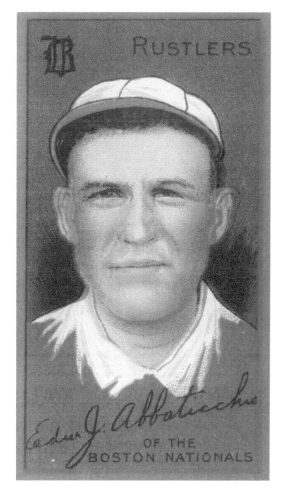

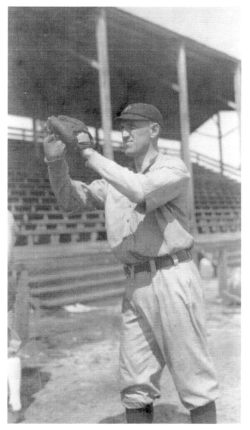

Right-handed pitcher Al "Steamer" Demaree had his best two years in baseball with the Phillies; in 1915 and 1916, he won 33 games. He was traded by John McGraw to the Phils as part of the Hans Lobert deal. The Phils, however, had a rare last laugh in this trade, as Lobert hurt his knee during the preseason and produced very little after that for the Giants. (Bob Warrington.)

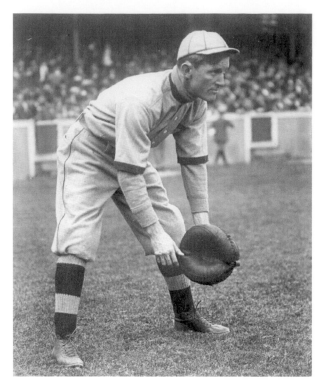

Nicknamed "Red," Charles Dooin played 13 seasons with the Phils, five of them as player/manager, leading them to a second-place finish in 1913. Though standing only 5 feet 6 inches, he was an excellent defensive catcher and handler of pitchers. Many historians think he pioneered the use of shin guards when he was behind the plate. Still, he suffered two broken legs but continued catching until his retirement in 1916. (NBHF.)

Known more for his ability to handle pitchers and less for his hitting skills, Bill Killefer was the Phils' backstop for seven years (1911–1917). He was the battery mate of Grover Cleveland Alexander 250 times during their careers. After his playing days, Killefer became a manager for the Cubs and the Browns. Unfortunately, he missed playing in the 1915 World Series because of a shoulder injury causing his arm to "go dead." (NBHF.)

THEY PLAYED THE GAME

Kid Gleason, from nearby Camden, New Jersey, pitched four seasons for the Phillies starting in 1888, compiling a 78-70 record. His 38 wins in 1890 are the most in a season in Phillies history. Gleason went to the Browns in 1892, but he returned to the Phils in 1903 as the regular second baseman for the next four years. He managed the 1919 ill-fated White Sox to the AL pennant before losing the World Series to Cincinnati in the "Black Sox" Scandal. (NBHF.)

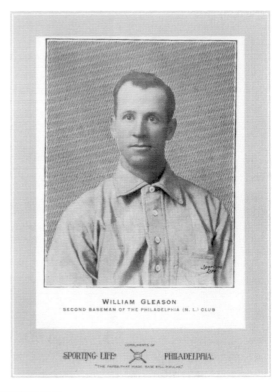

WILLIAM GLEASON
SECOND BASEMAN OF THE PHILADELPHIA (N. L.) CLUB

SPORTING LIFE PHILADELPHIA.

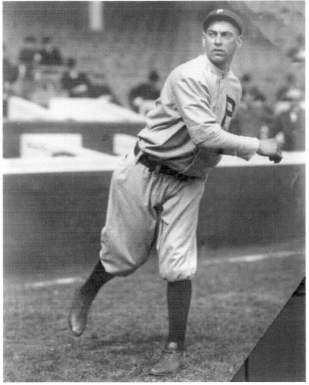

Joe Oeschger won 27 games for the Phils, but he is best known for his pitching in two extra-inning games, one of them a 20-inning tie game (9-9) against the Dodgers in 1919. But in 1920, while with the Braves, he pitched all 26 innings, including 21 consecutive scoreless innings (a major-league record), again against the Dodgers in another tie game (1-1). (NBHF.)

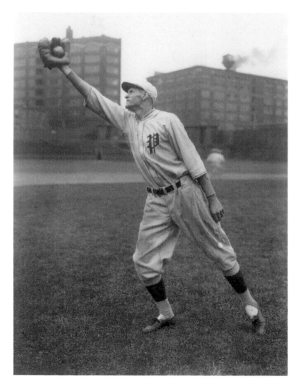

Cy Williams starred for 13 seasons as the best of the Phillies players during the Dark Ages of the 1920s. He was the first NL player to hit 200 home runs. A remarkable athlete, he played football at Notre Dame on the same team as Knute Rockne and even passed up a chance to go to the 1912 Olympics to sign with the Cubs. Joe Tinker called him the greatest natural outfielder he ever saw. He batted over .300 in six of seven seasons. His dead-pull hitting as a left-hander gave him three NL home run titles while at Baker Bowl, and he set the NL career home run record in 1923. NL managers employed the "Williams shift" years before Lou Boudreau used a similar one against another Williams in the 1940s and 1950s. The photograph below shows Williams trying to hammer some hits into his bat. (Both, NBHF.)

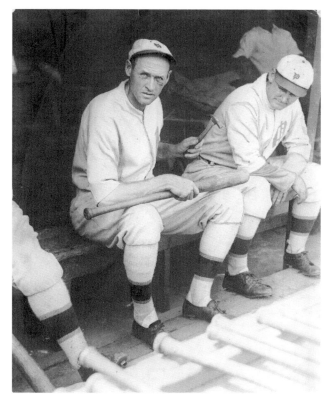

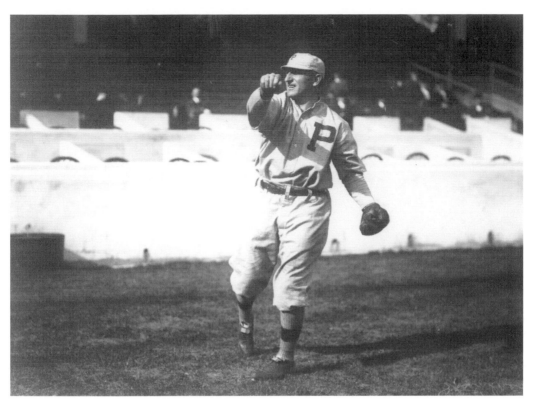

Despite his stocky build, Hans Lobert was fast. He was clocked at 13.8 seconds for a trip around the bases, and he beat Jim Thorpe in a footrace. Lobert came to the Phillies in 1911. In 1914, he was traded to John McGraw's Giants for three players. While he may have won his race with Thorpe, he finished last in the 1942 pennant race as a manager for the Phillies. (NBHF.)

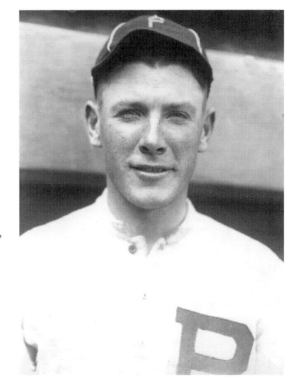

Older brother of the Yankees' Bob Meusel, Emil "Irish" Meusel drove in over 100 runs four times. Irish hit well for the Phillies, but when owner William Baker saw an opportunity to make money, he accused Meusel of being lazy and traded him to the Giants in 1921. Irish had a lifetime average of .310; his brother hit .309. (NBHF.)

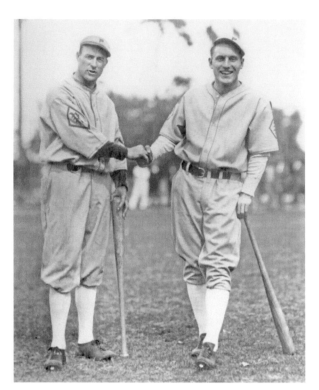

This photograph shows Phillies sluggers of the early 1930s. Lefty O'Doul (left) won the batting crown in both 1929 (.398 with 259 hits) and again in 1932 (.368). His teammate Chuck Klein won not only the NL batting crown in 1933, but also the Triple Crown (leader in home runs, batting average, and RBI). These men helped to give the Phillies a .315 team batting average in 1930, but the team still finished in last place. (PAHS.)

Don Hurst starred with the Phils during their batter-rich/pitching-poor years from 1929 to 1932 and immediately became a regular in 1928 at age 22. In 1932, he finished seventh in MVP voting when he led the National League in RBI while batting .339. His 19 home runs as a rookie set a club record surpassed only by Dick Allen's 29 in 1964. (NBHF.)

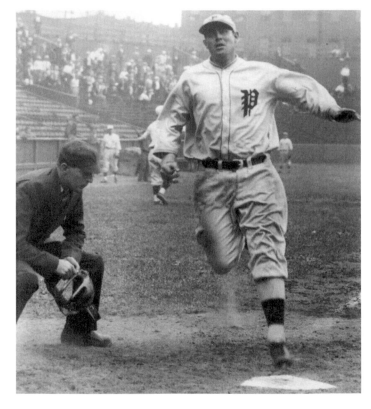

THEY PLAYED THE GAME

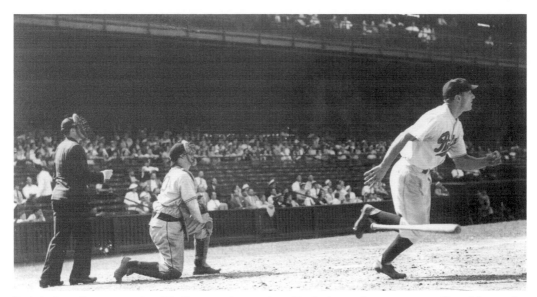

Dolph Camilli was another Phillies star during their Dark Ages who was eventually sold to make ends meet in the endless penurious times of that era. Baker Bowl suited his left-handedness, and he performed well for the team, averaging 25 home runs and 88 RBI in his three seasons. Traded to Brooklyn in 1937 for $45,000 and a player who never played for the Phils, Camilli became an all-star and a National League MVP for the Dodgers. (NBHF.)

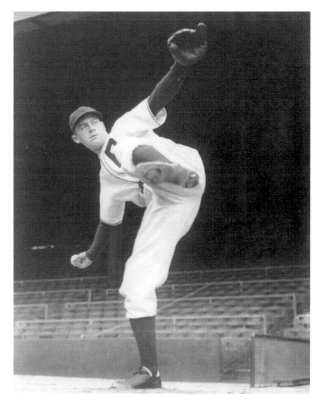

Considered an able pitcher, Hugh Mulcahy cheerfully accepted the moniker "Losing Pitcher" because, as he admitted, he did lose a lot of games. His attitude must have influenced sportswriters because he finished 25th and 29th in voting for league MVP in 1938 and 1940, respectively, despite dreadful pitching stats. He was on the NL All-Star Team in 1940. (NBHF.)

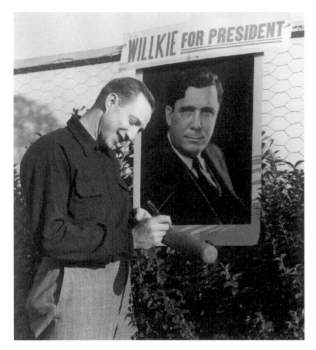

Seen here signing a bat while supporting Republican presidential candidate Wendell Willkie in 1940 is William Henry "Bucky" Walters, a native Philadelphian. Walters's five years with the Phillies were inauspicious. As a Cincinnati Red, he played on six All-Star Teams and won the National League MVP in 1939, his best year. The Reds lost to the Yankees in the 1939 World Series, but rebounded to win the 1940 Series over the Tigers. Walters won two games, one by a shutout. (NBHF.)

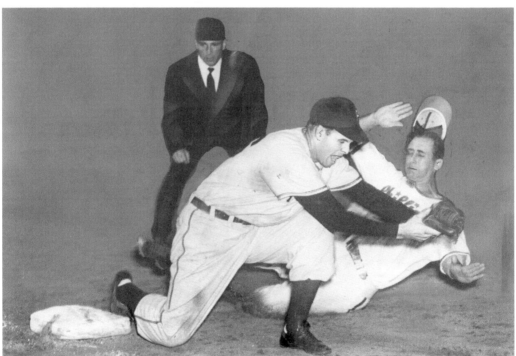

In a more conventional way to lose his hat, Phillies outfielder Harry "the Hat" Walker is called out sliding into third base. Walker was so dubbed because of the habitual doffing of his hat when he was at bat. In 1947, Walker won the NL batting title with an average of .363 and an OBP of .436. In 1949, Walker was traded away and spent four more years in the major leagues. (TUA.)

THEY PLAYED THE GAME

Casimir "Jim" Konstanty arrived in Philadelphia in 1948 at age 31. In 1950, he foreshadowed current baseball practice when he pitched in 74 games and 152 innings, all in relief. He was named the National League MVP that year. In his only start of that year, he pitched Game 1 of the World Series. (NBHF.)

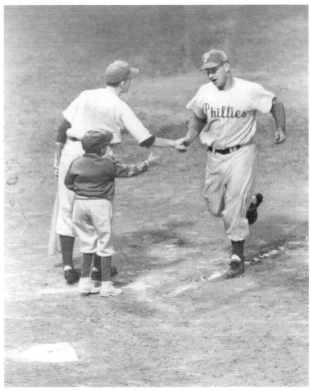

An all-star in his first year, Del Ennis earned the *Sporting News* Rookie of the Year Award in 1946. In his 10 years with the Phillies, he hit 259 home runs and averaged 100 RBI. A native Philadelphian, he signed with the Phils out of Olney High School in 1942. During Del Ennis Night on June 25, 1946, his 21st birthday, his batting helped the Phils win their sixth-straight game. (NBHF.)

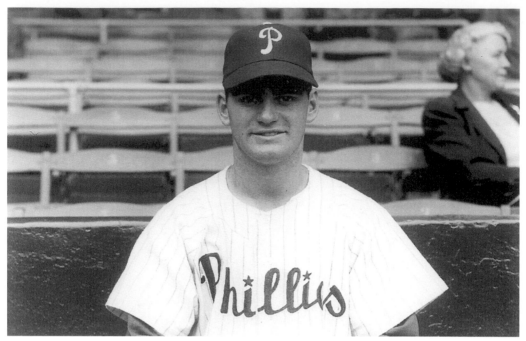

Ralph "Putsy" Caballero played eight seasons for the Phillies during the Whiz Kids era (1948–1955). He holds the record as the youngest person in major-league history to appear at third base and was a perennial fan favorite. His great speed allowed him to be used as an effective pinch runner. After three more seasons in the minors, Caballero retired from baseball after the 1955 season. In 2005, Hurricane Katrina destroyed his Louisiana home. (PAHS.)

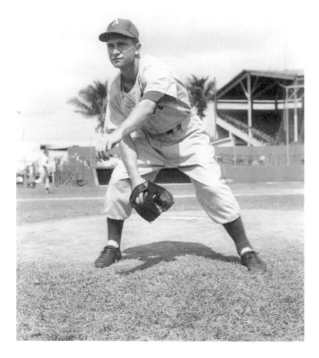

Bobby Shantz had already made his mark on baseball when he came to the Phillies in 1964. In 1952, he had posted a 24-7 win-loss record to earn him the American League MVP. The *Sporting News* named him their Pitcher of the Year. (The Cy Young Award eluded him only because it was not initiated until 1956.) He also won Gold Gloves for eight consecutive years, from 1957 until 1964. (PAHS.)

THEY PLAYED THE GAME

Bob Uecker played 96 games with the Phillies in 1966–1967 as a backup catcher. After retiring from baseball, he became a baseball announcer with a self-deprecating sense of humor. He once said of his Phillies days, "I didn't get a lot of awards as a player. But they did have a Bob Uecker Day Off for me once in Philly." Uecker is also known for his famous quote, "Just a bit outside," from the film *Major League*. (NBHF.)

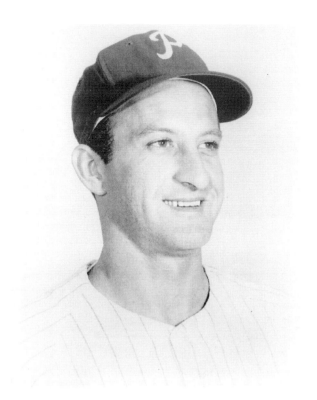

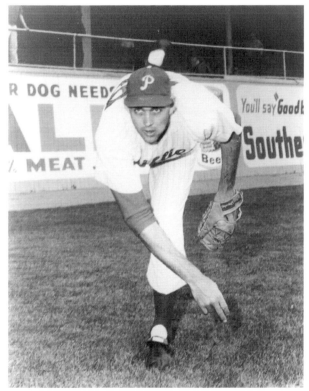

Gene Conley is one of the few successful American professional multisport athletes and the only one to win different sport championships—with the 1957 Milwaukee Braves in baseball and the 1959–1961 Boston Celtics in basketball. In his two-year stint with the Phillies, he won 20 games, five of them shutouts, and became an all-star in 1959. (NBHF.)

THE PHILADELPHIA PHILLIES

Jim Bunning is one of the few major-league pitchers to win 100 games and pitch no-hitters in both the American League and National League. Coming to the Phillies in 1964, he twice won 19 games for the team. His most noted achievement with the Phils is the perfect game he pitched on Father's Day in 1964, the first one in the regular season since 1922. (NBHF.)

One of the beneficiaries of the John Quinn trades in the 1960s, Tony Taylor proved to be a popular and productive player with the successful teams of the 1960s. Taylor was named to the All-Star Team in 1960 and continued with the Phillies until 1971. He returned to the Phils in 1974 and assumed duties as a base coach afterward. (NBHF.)

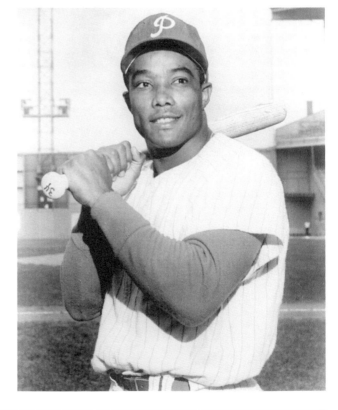

THE PLAYED THE GAME

An effective left-hander with the Gene Mauch teams, Chris Short won 132 games during his 14 seasons with the Phils to rate fourth on their all-time list. Along with right-hander Jim Bunning, he was part of the lefty-righty tandem rotation for the Phils in the mid-1960s. He won 20 games in 1966 and 85 from 1964 to 1968 and was a NL All-Star twice during that time. (NBHF.)

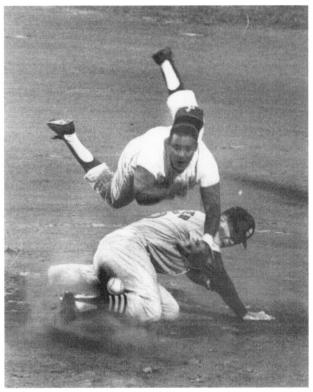

In this photograph, the father of the current Phillies general manager, Ruben Amaro Jr., is shown turning a double play against the Cardinals in September 1964. Ruben Amaro Sr. was a slick-fielding, weak-hitting shortstop who played six seasons in Philadelphia, averaging .241 and earning a Gold Glove in 1964. The future Phillies catcher and current national broadcaster, Tim McCarver, is Amaro's sliding victim. (TUA.)

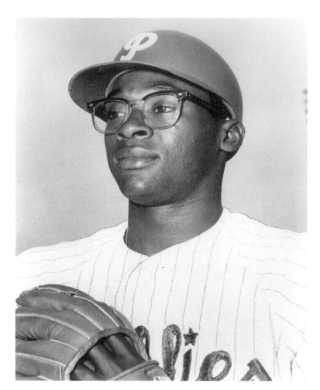

Dick Allen, the first African American superstar for the Phillies, was the National League Rookie of the Year in 1964. Allen's career with the team featured excellent play, especially at the plate, thrilling fans with his line drives and home runs, but his off-field antics created some controversy. His numbers have led many to push for his election to the Baseball Hall of Fame. Traded in 1969, he was named the American League MVP in 1972. He returned to Philly in 1975. (NBHF.)

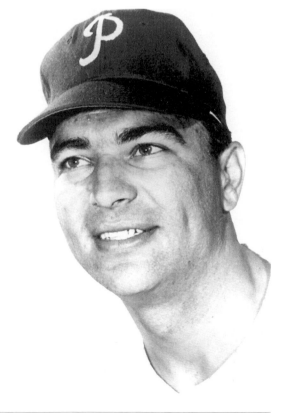

Perhaps Johnny Callison's greatest moment in baseball occurred at the All-Star Game of 1964, when he hit a three-run homer in the bottom of the ninth inning to give the National League a victory. Many Philadelphians believe that if the Phillies had won the NL pennant that year, Callison would have been the MVP. (NBHF.)

THEY PLAYED THE GAME

Art Mahaffey came to the Phillies as a bright prospect in 1960. A year later, he held the NL record for strikeouts in a single game (17). In 1962, he won 19 games and lost 14, but had 20 complete games. This photograph shows Mahaffey after hitting his only grand-slam home run on August 2, 1962. After the 1965 season, he was traded to the Cardinals with Pat Corrales and Alex Johnson for Dick Groat, Bob Uecker, and Bill White. (NBHF.)

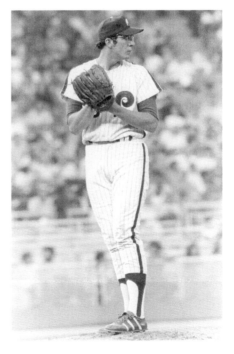

An excellent right-handed pitcher, Rick Wise came to the Phillies in 1964 at age 18 and pitched well for Gene Mauch. He spent seven seasons with the Phils, winning 75 games. He threw a no-hitter in 1971, personally hitting two home runs that day. But perhaps he is best known because he was traded to St. Louis for lefty Steve Carlton just prior to the 1972 season. What appeared to be a simple righty for lefty trade proved to be a decided advantage for the Phillies. (NBHF.)

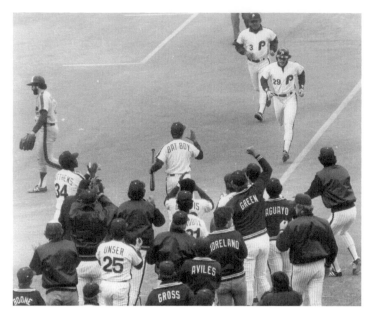

In a strike-shortened season, the Phillies were pitted against the Montreal Expos in the 1981 NLDS. In Game 4, the Phillies tied the series at two games apiece when George Vukovich (No. 29) hit a solo, walk-off home run in the bottom of the 10th inning. In Game 5 of the series, the Phillies were unable to score a run, and the Expos went on to play the Los Angeles Dodgers for the NL pennant. (TUA.)

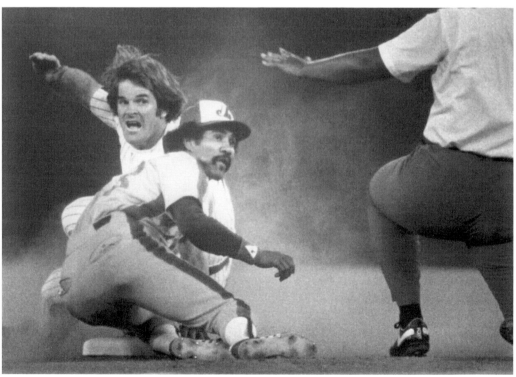

Pete Rose steals second base in the fourth inning of a game against Montreal in 1981. The Expos' second baseman is Jerry Manuel, manager of the New York Mets from 2008 to 2010. Calling Rose safe is umpire Eric Gregg, a native of West Philadelphia who spent 15 years as a NL umpire. Rose won the Silver Slugger Award that year. The very next day, Steve Carlton recorded his 3,000th strikeout. (TUA.)

THEY PLAYED THE GAME

John Kruk came to the Phillies in 1989 after three years with the San Diego Padres. In his six seasons with the Phillies, he had a batting average of .309 and was an all-star for three consecutive years. With a batting average of .348, he was instrumental in the Phillies winning the NL pennant and getting into the World Series against Toronto in 1993. Kruk was part of the Phillies team that often annoyed fans because of their unkempt appearance. When asked why athletes were so slovenly, Kruk reportedly replied, "We ain't athletes, lady. We're baseball players." In fact, in 1994, Kruk published the book *I Ain't an Athlete, Lady*. He is currently an ESPN baseball analyst and writes a column called "Chewing the Fat" on espn.com. He has appeared in several films and television shows. (NBHF.)

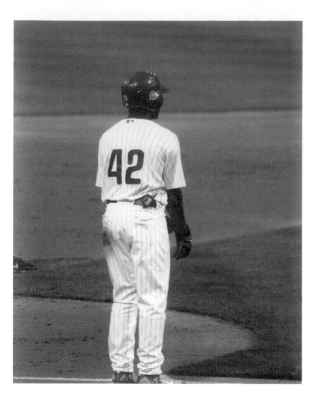

Phillies shortstop Jimmy Rollins is shown with his No. 42 jersey in 2007. This photograph was taken the day before the No. 42 jersey was to be worn by all players to honor Jackie Robinson. Later that year, Rollins was named the National League MVP and won his first of three consecutive Gold Gloves. Oddly, although Rollins was selected for three All-Star Games, he was not on the 2007 team despite his stellar year. (Photograph by Joe Hetrick, used with permission.)

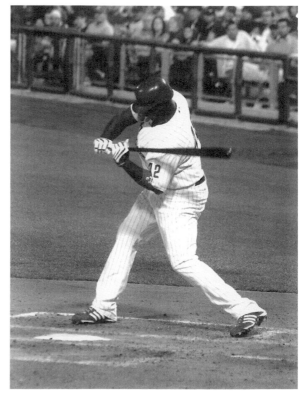

Ryan Howard is shown paying homage to Jackie Robinson by wearing a No. 42 jersey in 2007. Howard won the Rookie of the Year Award that year and was named the National League MVP a year later. In 2008, he hit 58 home runs and led the league with 149 RBI. His 58 home runs tied him with Jimmie Foxx as the highest total for a Philadelphia player. Foxx had also hit 58 in 1932 for the Philadelphia Athletics. (Photograph by Joe Hetrick, used with permission.)

THEY PLAYED THE GAME

3

A TRIP TO COOPERSTOWN

In the 128 years of their existence, the Phillies can lay claim to 30 Hall of Famers, including players, coaches, managers, and executives. Yet, not all of these men played their best years in Philadelphia. Often they arrived in Philadelphia in the final years of their careers and offered the Phillies very little in the way of productive baseball. Others started their careers as Phillies but then moved on or were traded away to other teams to achieve their stellar reputations.

In the early years, many future Hall of Fame players passed through Philadelphia. In the 1890s, players like "Sliding Billy" Hamilton, Nap Lajoie, and Elmer Flick all began their careers in Philadelphia but went on to bigger and better things. Others that got away include later players like Fergie Jenkins and Ryne Sandberg. Lajoie and Flick made their careers with the Cleveland Indians, Hamilton moved on to the Boston Beaneaters, and Jenkins and Sandberg went to the Chicago Cubs. Still, others like Ed Delahanty and Sam Thompson spent most of their playing time with the Phillies. But the Phillies players who made a permanent mark on Philadelphia baseball have a long-standing reputation in the city. Players such as Delahanty and Dave Bancroft have maintained their standings. Then there are those players who the Phillies have honored by retiring their numbers (or uniforms): Grover Cleveland Alexander, Chuck Klein, Richie Ashburn, Robin Roberts, Jim Bunning, Steve Carlton, and Mike Schmidt.

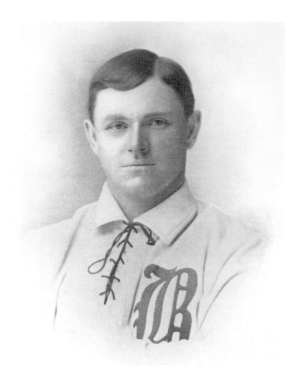

WILLIAM R. HAMILTON, Center Fielder,
BOSTON. 1900.

Billy Hamilton starred in the Phillies' Hall of Fame outfield from 1891 to 1895. The nickname "Sliding Billy" is derived from his prodigious stolen base talent, garnering 510 bases in his Phillies career. He ranks third in major-league career stolen bases with 914. He led the league twice in batting and finished his career with a .344 average, tying Ted Williams. (NBHF.)

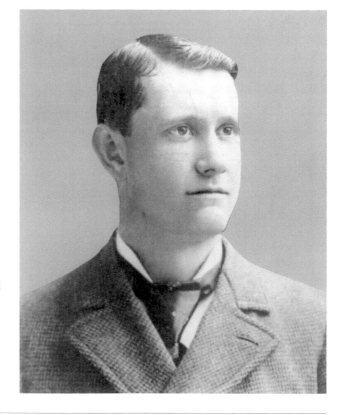

Ed Delahanty is considered one of the greatest players of all time and another member of the best outfield of all time. In 1894, he joined Hamilton and Thompson with .400+ batting averages, the only trio in Major League Baseball history to accomplish this feat. Beset with drinking problems and an unstable personality, he met a tragic end by falling off a railroad bridge on the Canadian border in 1903. (NBHF.)

Roger Connor played one season with the Phils in 1892 and had the highest number of plate appearances in his career. He led the National League with 37 doubles. Always a deft fielder, this first baseman solidified the Phillies' infield for that season, achieving the highest number of fielding chances and putouts in his career. His 12 home runs with the Phils contributed to his career total of 138, not exceeded until 1921 by Babe Ruth. (NBHF.)

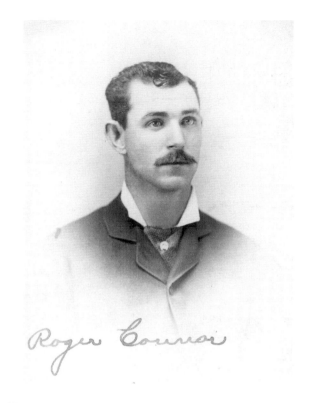

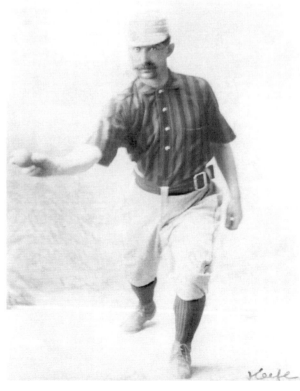

Tim Keefe had a 14-year career as a pitcher in the National League, the American Association, and the Players League. He finished that career with the Phillies in 1893. He won over 30 games in a season six times, winning 41 in 1883 and 42 in 1886. He had 342 career wins and was elected to the Hall of Fame in 1964. His ERA of 0.86 in 105 innings is still a record. He also pioneered the change-up pitch. (NBHF.)

The Phillies' right fielder from 1898 to 1901, Elmer Flick jumped to the Philadelphia Athletics of the American League in 1901. Flick earned his way into the Hall of Fame by virtue of his speed in the outfield, his lifetime .313 average, and his high slugging percentage. He won the AL batting title in 1905. Perhaps his greatest claim to fame occurred in 1906, when the Cleveland Indians refused to trade Flick to the Detroit Tigers for Ty Cobb. (NBHF.)

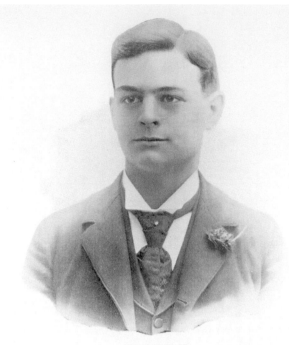

ELMER H. FLICK,
RIGHTFIELDER, BOSTON, 1899.

Charles Augustus "Kid" Nichols is another one of the Phillies' Hall of Fame players (in 1949) who logged only two years with the club in 1905 and 1906. Playing mostly with the Boston Beaneaters, Nichols won 361 games over his 15-year career. He won 30 or more games in a single season seven times. (NBHF.)

Sam Thompson played outfield for the Phillies in what is considered one of the best outfields in the history of the game. He is one of the five future Hall of Famers the Phils featured in the mid-1890s. Known for his glove as well as his bat, he led the National League in assists and fielding average twice during his Phillies tenure. For his career, he leads all of baseball in RBI per game with a mark of .923, nearly one per game. (NBHF.)

Starting his career with the Phillies in 1896, Rhode Islander Nap "Larry" Lajoie began establishing his lifetime .338 average immediately. When he jumped to the Philadelphia Athletics for more money, Phils owner John Rogers sued for the return of his "property." Finally, the Pennsylvania Supreme Court prevented Lajoie from playing ball in Pennsylvania for any team other than the Phillies. He circumvented this ruling by signing with Cleveland, skipping his team's games in Philadelphia and going to Atlantic City. (LOC.)

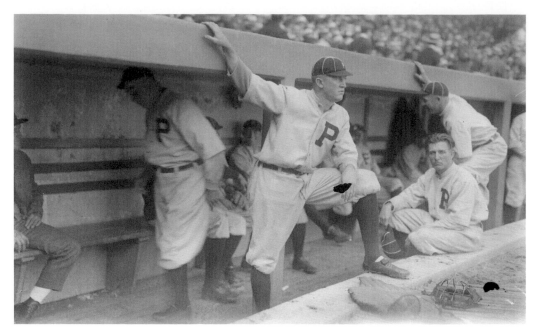

Grover Cleveland Alexander is seen on the dugout steps and hefting a bat in these two photographs taken at Baker Bowl. Alexander is one of the early inductees to the Hall of Fame, elected in 1938 on the basis of his 373 career victories, 190 of them with the Phillies. From 1915 to 1917, he won 30 or more games for three consecutive years. In 1916, he set a still-standing major-league record of 16 shutouts as he won 33 games. After the 1917 season, William Baker traded Alexander with the cynical reasoning that he would lose him to World War I service through either death or injury. Predictably, cash considerations were the primary motive for the trade. Alexander would gain everlasting fame in the 1926 World Series and earn three 20-win seasons after he left the Phillies. (Both, LOC.)

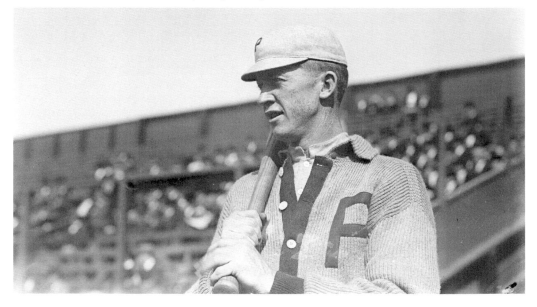

A TRIP TO COOPERSTOWN

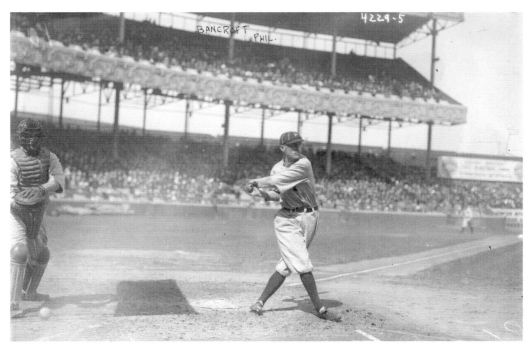

Dave Bancroft, a deft-fielding shortstop earned the nickname "Beauty" because that was the word he shouted when his pitcher threw a good pitch. He is considered one of the best fielding players in baseball history, known for his graceful moves in either direction. For the Phillies, he anchored the pennant-winning 1915 squad and played with them from 1915 to 1920. He became a New York Giant after owner William Baker received an offer of $100,000 for him. (NBHF.)

Manager Pat Moran talks with Johnny Evers of the legendary Tinker-to-Evers-to-Chance double play combination. Evers played with the Phillies at the end of his career in 1917. He later managed the Cubs and the White Sox. He was elected to the Hall of Fame in 1946. (Bob Warrington.)

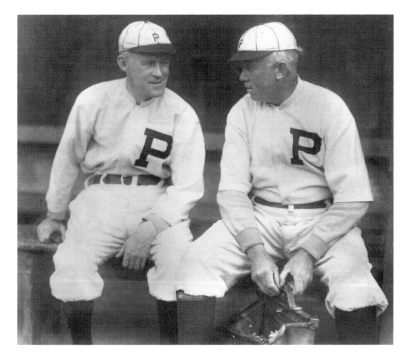

Eppa Rixey is a Hall of Fame pitcher whose career with the Phillies was anything but. He played eight seasons and left with an 87-103 record. He had one outstanding season in 1916, with 22 victories, second in the club to Alexander. His credentials were actually earned with Cincinnati, where he won 179 games and had three seasons of 20 or more victories. (Bob Warrington.)

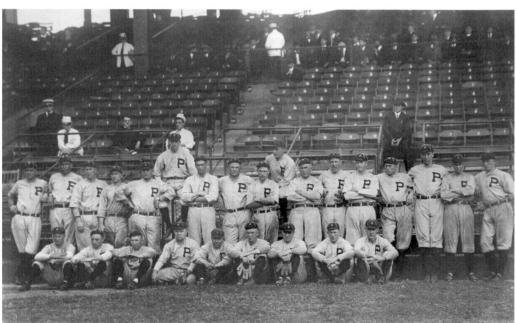

This photograph shows the 1916 Phillies team; note the presence of Charles Albert "Chief" Bender standing second from left. Bender pitched for the Philadelphia Athletics for 12 years and finished his playing career with the Phillies. He went 8-2 in 1917 (his last year) with an ERA of 1.67 in 113 innings. He was elected to the Hall of Fame in 1953. (Bob Warrington.)

A TRIP TO COOPERSTOWN

Chuck Klein was the most significant Phillies player during the pre–World War II years. Using his left-handed power and a short right field fence at Baker Bowl, Klein led the league four times in homers. In 1932, he was chosen as the National League MVP, but his best year was 1933, when he won the Triple Crown. He played in the first two All-Star Games and was elected to the Hall of Fame in 1980. (NBHF.)

Richie Ashburn was a stalwart with the Phillies for 12 seasons. Lacking power (only 29 home runs in his 15-year career), but possessing great speed (led in stolen bases in 1948), Ashburn was an excellent singles hitter and an ideal leadoff man. He won two batting titles in 1955 (.338) and 1958 (.350) and carried a lifetime .308 average to the Hall of Fame. Even in his final year with the New York Mets, Ashburn hit .306 at age 35. He also led the National League in triples in 1950 and 1958. (NBHF.)

George "Sparky" Anderson played for the Phillies in 1959, his only year in the major leagues. After spending a few years in the minors, Anderson returned as a manager in 1970 of what was to become the Big Red Machine. With the Reds for nine years, he won four NL pennants including two World Series titles. In 1979, he went to the American League, where he managed the Detroit Tigers for 17 years, including another World Series in 1984. (NBHF.)

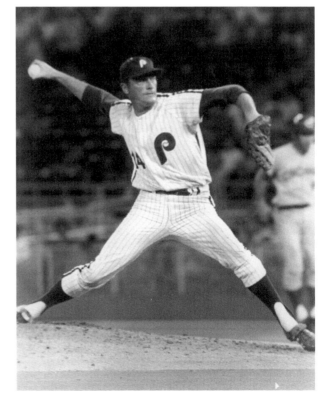

Jim Bunning won at least 100 games in both the American League and National League as one of nine pitchers to do so. He is also one of five pitchers to have a no-hitter in both leagues. He won 89 games for the Phillies, including the first regular-season perfect game since 1923 against the New York Mets on Father's Day in 1964. (NBHF.)

Robin Roberts is one of the greatest right-hand pitchers in Phillies history. He won 20 games in six consecutive seasons and was voted an all-star seven times. He won in 10 innings in the last game of the season in 1950 at Ebbets Field, a game that clinched the second NL pennant for the Phils. (NBHF.)

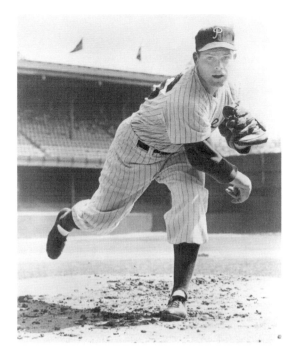

Roberts is seen here with his son Robin Jr. during a winter break from his mound work with the Phillies. His Cadillac implies he was not a singles hitter. Indeed, Roberts was the Phillies' workhorse for most of his career. He holds the Major League Baseball record for 28 consecutive complete games. (FLP.)

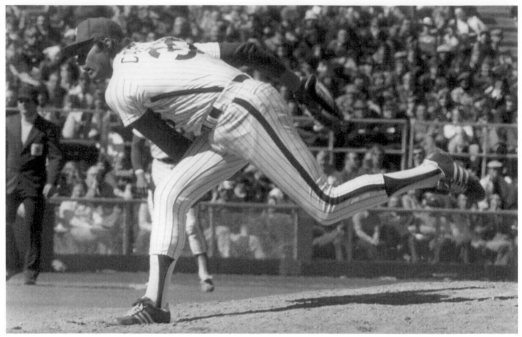

Hall of Famer Steve Carlton startled the baseball world in 1972 by winning 27 games on a Phillies team that won only 59. The left-hander pitched the Phillies to their first World Series title in 1980 and gathered four Cy Young Awards. While popular with the fans, he refused press interviews due to his vow of silence in response to media criticism of his training regimen, which consisted of him thrusting and twisting his arm into a 5-gallon container of rice. (NBHF.)

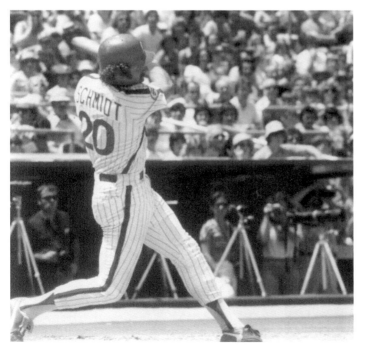

Hall of Famer Mike Schmidt hit for power (548 home runs) and fielded brilliantly (nine Gold Gloves) during his time with the team. He achieved nine NL All-Star selections, six NL Silver Slugger awards, eight NL home run titles, three NL MVP titles, and MVP of the 1980 World Series. A disciplined fitness buff, he once worked out with his pants around his ankles because to lift them would interrupt the fitness routine. He entered the Hall of Fame in 1995 (NBHF.)

AT THE HELM

Today's Phillies management and field leadership are enjoying one of the most exciting eras of baseball success during the long history of the Philadelphia Phillies. Players like Chase Utley, Jimmy Rollins, Cole Hamels, Ryan Madson, Carlos Ruiz, and Ryan Howard—all homegrown talent from the farm—have made the Phillies a perennial contender in Major League Baseball. Owners Bill Giles and David Montgomery have loosened the purse strings; general manager Ruben Amaro Jr. is making trades and acquisitions that help the team, e.g., Cliff Lee, Roy Halladay, and Roy Oswalt; and manager Charlie Manuel's leadership style is being credited for getting the most from a talented bunch of players who have won four straight division titles, two NL pennants, and one World Series.

But the circumstances were not always this favorable. The Phillies' history of management and administration is replete with inept and incompetent owners, managers, and players who were only occasionally interspersed with those who knew what they were doing.

Founders Al Reach and John Rogers built a strong foundation that became slowly eroded by a bad succession of owners with little vision, chiefly William Baker and Gerry Nugent, curators of the Dark Ages.

Robert Carpenter, along with his son Bob Jr. and grandson Ruly, brought more light and life into the Phillies, consummating their ownership with a World Series victory in 1980. And the Giles-Montgomery team has successfully passed through some tough times to bring another victory parade to Philadelphia in 2008.

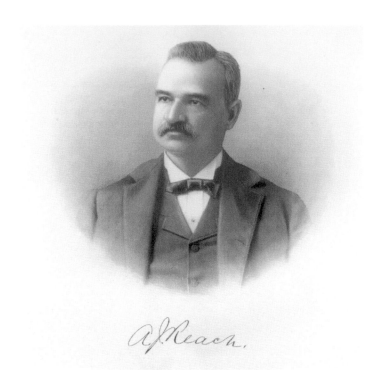

Al Reach is often considered the first professional ball player. He played for the Philadelphia Athletic Club in the 1860s, and in exchange, he was given a tobacco store. After his playing career, he became a sporting goods magnate and teamed with John Rogers to purchase the defunct Worcester NL franchise. Reach and Rogers moved the franchise to Philadelphia in 1883. (Bob Warrington.)

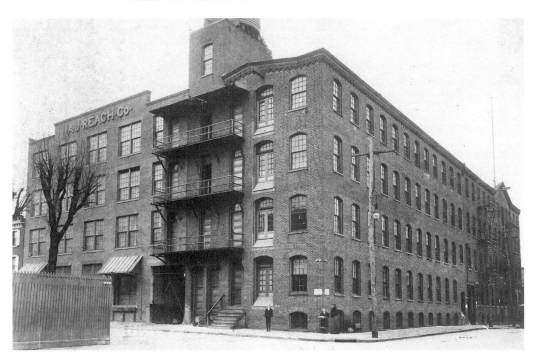

The Reach manufacturing plant, located in the Kensington section of Philadelphia, produced baseballs and other athletic equipment while the owners dominated the Philadelphia baseball scene. Al Reach was an owner of the Phillies, and his partner, Ben Shibe, was a major shareholder of the Philadelphia Athletics of the American League. (Bob Warrington.)

AT THE HELM

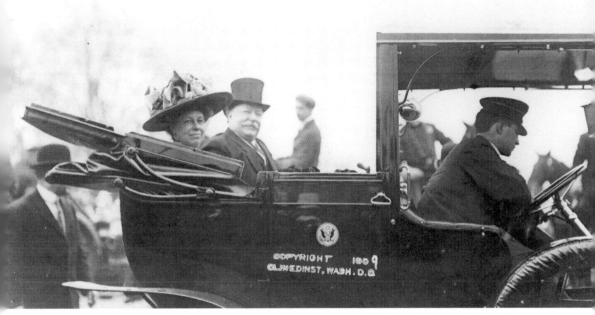

Seen here with his wife at his inauguration in 1909 is Pres. William Howard Taft, who may have had a share of the Phillies' ownership. In 1910, the Taft family of Cincinnati owned part of the Phillies through an arrangement headed by Chicago Cubs owner Charles Murphy. The Taft and Murphy families sold the Phillies to William Baker in 1913, but the catch was the sellers continued to maintain ownership of the Philadelphia Baseball Park and simply leased it to Baker. They constructed an ironclad lease arrangement that resisted modifications and kept the Phillies tethered to the dilapidated stadium until 1938. President Taft became a baseball fan after Murphy convinced him of the benefits he could accrue as an ambitious politician who was a fan of the national pastime. Consequently, President Taft began attending baseball games in Washington, D.C. Baseball historians attribute two traditions to President Taft: ceremonial first pitches by a sitting president and the seventh-inning stretch. (LOC.)

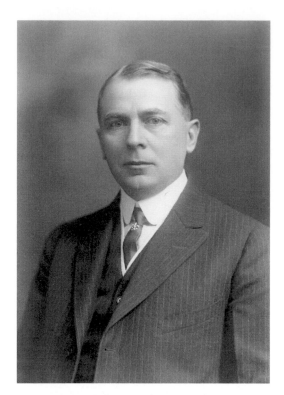

Many Phillies fans blame William Baker's ownership (1913–1930) for the sorry reputation the team developed. Simply said, he held on to his money and did not spend it on his team or the stadium. He traded or sold great and good players for cash or lesser players, he accepted an unfavorable lease for his ballpark, and finally, his will continued his inept legacy with respect to Gerry Nugent (see next page). (David M. Jordan.)

Baker's wife, Mary, sat with him at the Philadelphia Baseball Park during the 1915 World Series. She is depicted here throwing out a ceremonial first ball—an uncommon occurrence for a woman in the men's world of Major League Baseball. (LOC.)

AT THE HELM

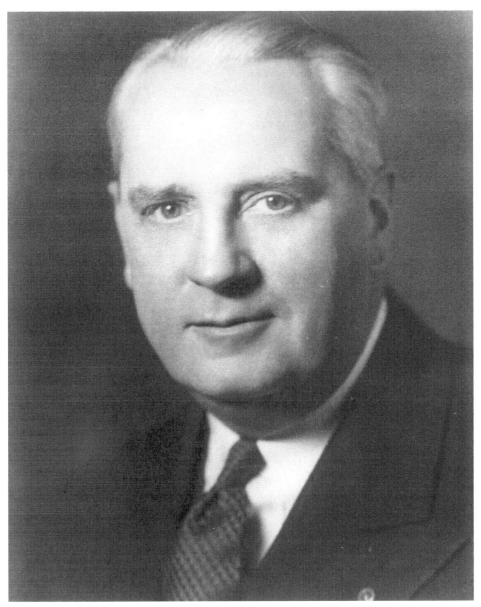

Gerry Nugent received ownership of the Phillies through a series of estate wills. He was hired by Baker to run the office side of the team. As a result, he married the team secretary, Mae Fallon, and they had a son, Gerry Jr. When Baker died in 1930, he left 50 percent of his stock to Mae Fallon Nugent and the rest to his widow, Mary. Believe it or not, when Mary died in 1932, she left her stock to Mae Fallon Nugent and Gerry Jr. Where Baker held on to his money, Nugent had no money, but a very resourceful brain. He signed good, young players and kept the team afloat through a series of player deals that siphoned off those now older, productive players but received cash in return to pay for the team's operation. Unfortunately, his brain could not outsmart his wallet, and he eventually approached the National League for bailouts. In 1943, the well went dry and he sold the Phillies to the league. (Dave M. Jordan.)

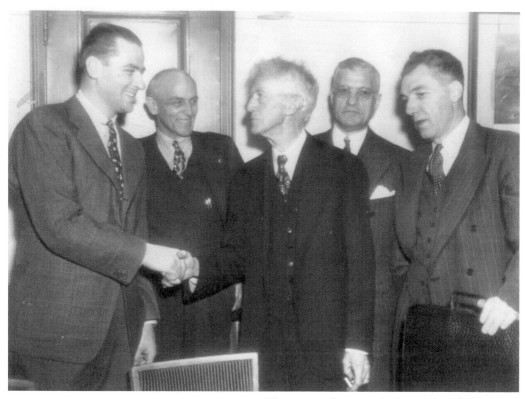

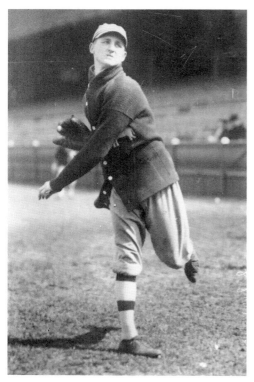

This group photograph shows, from left to right, Bob Carpenter Jr., Robert Carpenter Sr., Judge Kennesaw Mountain Landis, AL president Will Harridge, and NL president Ford Frick at the baseball winter meetings in 1943. Robert Sr. had just purchased the Phillies and installed his son as club president. This was the only time that Robert Jr. and Landis would meet; Landis went off to war in January 1944 and died later that year. (Bob Warrington.)

Herb Pennock, Hall of Fame pitcher, played 20 seasons in the American League for the Philadelphia Athletics, Boston Red Sox, and New York Yankees. In 1944, he became the general manager of the Phillies and began to develop players who would change the texture of the team. When he died suddenly in 1948, he left the basis for a team who would go to the World Series in 1950. (LOC.)

Though born in England, Harry Wright is one of the "fathers of baseball." As a player and player/manager, he pioneered the sport in Cincinnati and Boston. In 1884, Reach hired him as manager after the disastrous maiden season for the Phillies in 1883. Wright breathed new life into the franchise. In his 12-year tenure, the Phils finished in the first division of the National League 10 times. (NBHF.)

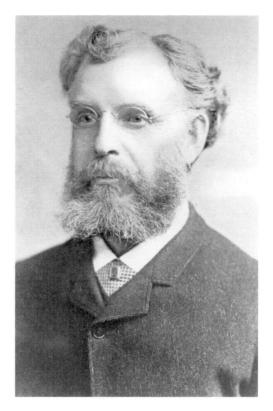

This team photograph of the 1887 Phillies actually belonged to Harry Wright, whose handwriting is seen below the picture. The team finished second in the National League behind the Detroit Wolverines at 75-58. This marked the best finish for the Phillies in the 19th century. A star of the team is Charlie Ferguson (standing, far right), a player of rare talent. His death at age 25 in 1888 stunned the Phillies. (Bob Warrington.)

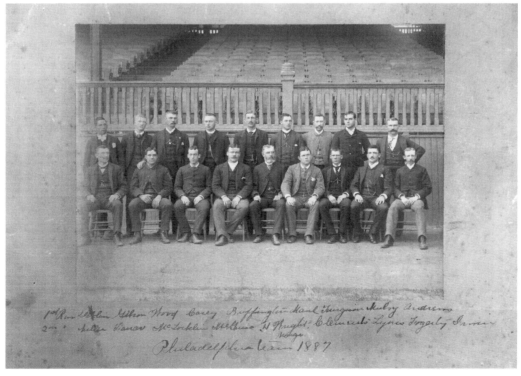

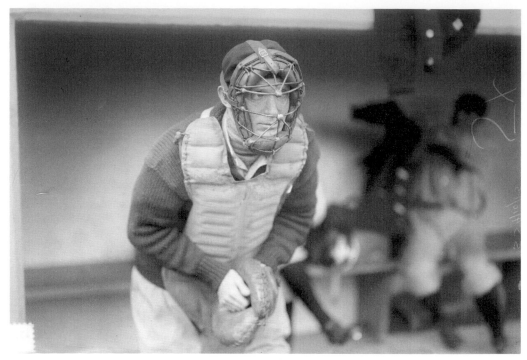

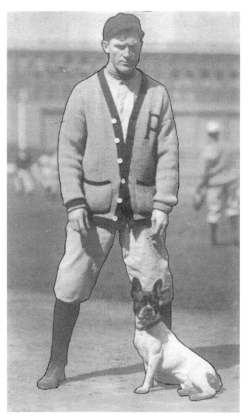

Red Dooin, shown here in the tools of his trade, was the player/manager from 1910 to 1914. He brought the Phillies into contention, leading them to a second-place finish in 1913. He had shared, with Pat Moran, the development of Grover Cleveland Alexander. In the photograph at left, he poses with his dog at Baker Bowl. After the 1914 season, Baker traded (a novel way to fire him) his player/manager to the Cincinnati Reds, and thus, Dooin was denied participation in the Phillies World Series appearance. In the off-seasons, Dooin performed on the Philadelphia vaudeville circuit with the Dumont Minstrels. After retiring from the game, he continued with vaudeville and also sang on the radio. (Above, LOC; left, Bob Warrington.)

During his five years as a catcher with the Phillies, Pat Moran became an excellent judge of pitching talent. In 1911, he took the young Phillies right-hander Grover Cleveland Alexander under his wing and helped develop Alexander's skills. After becoming the Phillies manager in 1915, he led the team to their first NL pennant. His record of 323-257 as the Phillies' manager is one of the Phils' best. Baker released him after the 1918 season, when the Phillies finished sixth. John McGraw (below with Moran) hired him as a pitching coach for the New York Giants, but the Cincinnati Reds made him their manager in 1919. The Reds won the NL pennant that year and beat the White Sox in the tainted World Series. The Reds had two second-place finishes under Moran, who could have entered the Hall of Fame had it not been for his early death in 1924 at 48. (Right, Bob Warrington; below, LOC.)

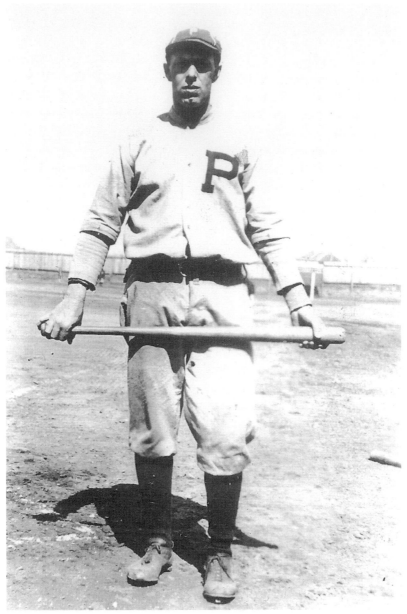

"Colby Jack" Coombs pitched for the Philadelphia Athletics for nine years. In 1910, the A's won the World Series; Coombs had posted a 31-9 win-loss record with 13 shutouts. He defeated the Chicago Cubs three times during the Series. In 1911, he won 28 games and lost 12; he won another game in the Series. Released in 1914, he signed with the Brooklyn Robins. In 1919, William Baker hired Coombs to manage his depleted Phillies team. Within a few weeks, as Baker continued to deal his better players for the less talented, Coombs saw the handwriting on the wall. Coombs quit after 62 games and left town. As he was a great favorite with his players, the team (not management) honored him with a testimonial dinner after the season was over. He went on to a very successful college coaching career at Duke University. (Bill White.)

Gavvy Cravath replaced Coombs, reportedly with some reluctance, midway through 1919 and stayed on for one more season as a player/manager. Deprived of talented players because of Baker's dealing them away, the team finished last both times. Baker fired him after the 1920 season, but not before the gifted Cravath closed out his lustrous career in possession of the major-league career home run title at the time. (NBHF.)

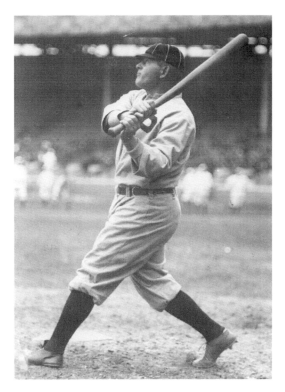

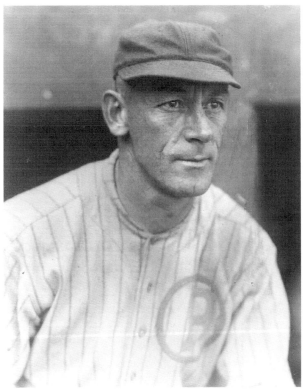

Irv Wilhelm, nicknamed "Kaiser" for obvious reasons, became an interim player/manager for the Phillies in 1921 at the age of 47, replacing Bill Donovan. He then led the Phils to one of their rare appearances out of last place during the 1920s, when they finished seventh in 1922, his final season. (NBHF.)

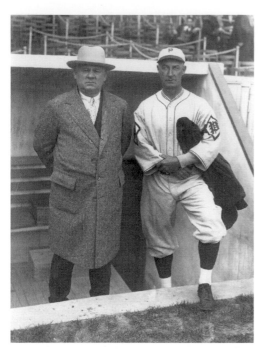

Shown here in the Polo Grounds dugout are ex-Giants manager John McGraw (left) and Burt Shotton, who managed the Phils from 1928 to 1933. Shotton, who would wear street clothing when he managed the Brooklyn Dodgers from 1947 to 1950 (one of only two managers in 20th century baseball to do so), lost his job when the Phillies beat him in 1950. (NBHF.)

Casey Stengel (left) and Burt Shotton, competing managers in the 1949 World Series, shake hands before a game. Both men had ties to the Phillies. Stengel played parts of two seasons at Baker Bowl in 1920 and 1921 and hit the most home runs in a season in his career in 1920. Shotton managed the Phils for six years and piloted them to their only winning season during the Dark Ages. (NBHF.)

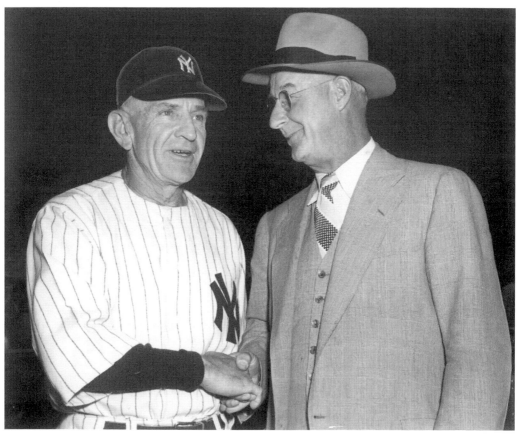

AT THE HELM

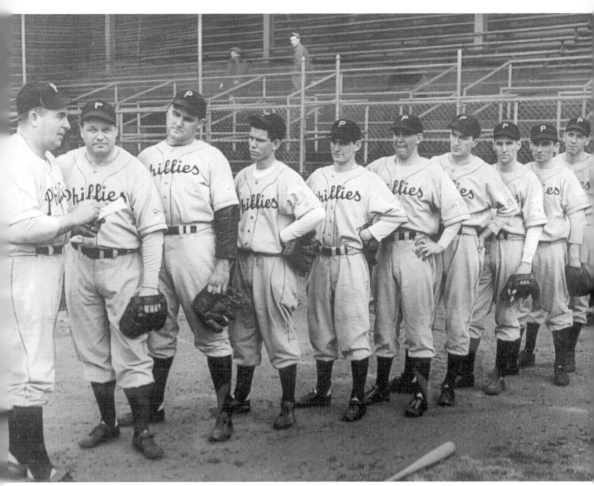

In 1945, Phillies manager Fred Fitzsimmons (far left) chats with his team. With new owner Bob Carpenter and World War II over, the Phillies were getting ready to begin their climb out of despair and into the first division and to the top. Next to Fitzsimmons is Hall of Famer Jimmie Foxx, who had played in the American League for 17 seasons. After two years with the Cubs, Foxx spent his last active year with the Phillies. Known for his slugging, Foxx actually pitched in nine games for the Phils that year. In 22.2 innings, he compiled a record of 1-0 and an ERA of 1.59. In the 1950s, Foxx managed the Fort Wayne Daisies of the All-American Girls Professional Baseball League. He held the record for most home runs in a season by a Philadelphia player (58) until Ryan Howard tied him in 2006. (PAHS.)

To alert his bullpen when he wanted to change pitchers, Eddie Sawyer used hand signals in the days before modern phone devices. The raised right arm signaled right-hander Bob Miller, the steeple-like pose called for Bubba Church, the eyeglasses summoned the bespectacled Jim Konstanty, the he-man pose beckoned the muscular Milo Candini, and the left arm brought southpaw Curt Simmons. Sawyer managed the Phillies from mid-1948 to 1952, again in 1959, and for a single day in 1960. In 1949, he led the Phils to their best season since 1932; the following year, his team won the NL pennant, their first in 35 years. Unfortunately, the team was unable to gain even a single win from the New York Yankees in the 1950 World Series. Prior to his baseball career, Sawyer had been a science professor at Ithaca College and was a member of Phi Beta Kappa (an academic honor society). (TUA.)

Steve O'Neill was one of the more successful managers of the Phillies, with 182 wins for a .565 winning percentage during his time with the Whiz Kids. They were a more experienced bunch with O'Neill and responded well to his laid-back style. Unfortunately, general manager Roy Hamey fired him in 1954 because he felt the team needed "spirited leadership." Soon after, the Phillies plunged into mediocrity for another decade. (NBHF.)

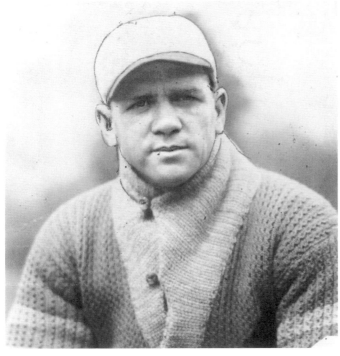

O'Neill's playing career hinted at his future competence as a manager. He caught for 17 seasons in the American League, mostly with the Cleveland Indians, and he hit .333 during the 1920 World Series victory for the Tribe. O'Neill never had a losing season in 13 stints as a manager, including his 1945 World Series champion Detroit Tigers. The Phillies never should have let him go. (NBHF.)

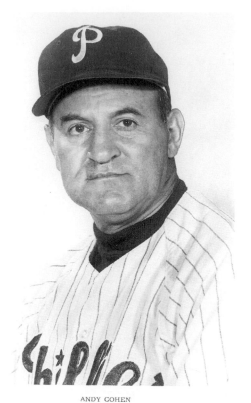

ANDY COHEN

Infield coach Andy Cohen became the Phillies' manager for one game in 1960 when manager Eddie Sawyer decided to retire after losing the first game of the season. "I'm forty-nine and want to live to be fifty," said Sawyer. Phillies management proved unable to obtain a replacement until the third game and asked Cohen to serve in the interim. Gene Mauch arrived the next day. Despite his loyalty and success, the Phillies fired Cohen at the end of the season. (NBHF.)

Dubbed "the General," Gene Mauch is widely known for raising the Phillies from terrible to competent contenders during his tenure. His record of .462 belies his success. He had winning records in six of his eight full seasons with the team, including the near-pennant team of 1964. The Phillies fired him in 1968 while he was visiting his sick daughter in California. (NBHF.)

AT THE HELM

Danny Ozark managed the Phillies from 1973 to 1979. He presided over three of the most successful, though disappointing, seasons in the Phillies' history. Led by future Hall of Famers Steve Carlton and Mike Schmidt, Ozark's teams won three NL East division championships from 1976 to 1978, but they could not get beyond the first tier of the playoffs. (George Brace Photo Collection.)

Feisty Larry Bowa, spark plug for the powerhouse teams of the 1970s and 1980s, garnered two Gold Gloves and five all-star honors with the Phillies. He set single-season and career records in fielding percentage for major-league shortstops and retired with the most games played at that position in history. He managed the Phils from 2001 to 2004 and was named NL Manager of the Year in 2001 for bringing the Phils in second. (NBHF.)

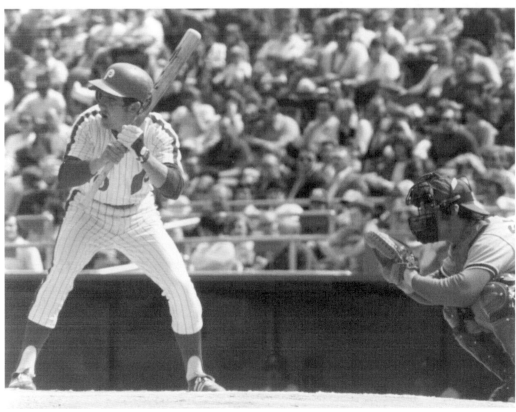

THE PHILADELPHIA PHILLIES

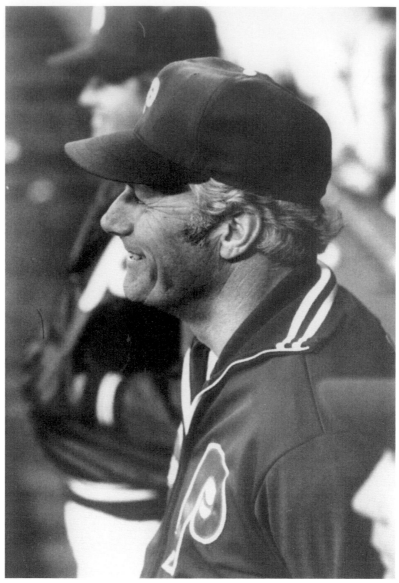

Boisterous, bombastic Dallas Green replaced the laconic Danny Ozark, and Green's commanding presence finally brought success to the title-starved Phillies. They won the World Series in 1980, but it did not come easy. On August 10, the Phillies were 55-52 and Green blew up during a closed-door meeting. The players had a meeting of their own soon after and vowed to win it for themselves. Whether it was the two meetings or their talent that provided the spark will never be known, but the Phillies went 36-19 the rest of the way and entered Phillies history as their first world champions. Green was good news and bad news for Phillies fans. The World Series win took a major monkey off the back of the franchise, but when Green became general manager for the Cubs in 1982, he obtained future Hall of Famer Ryne Sandberg from the Phillies in a trade for shortstops. The Phils became mediocre again for a few seasons after this trade, and there is no telling what success Sandberg could have given the Phillies. (TUA.)

Paul Owens's nickname, "the Pope," indicates leadership, and his record shows it. He built the 1980 Phillies championship team as the general manager and stepped down twice to actually manage the Phillies, once in 1972 and again in 1983. The 1983 Phillies team sputtered along until Owens named himself the manager and led the team to another World Series appearance. (George Brace Photo Collection.)

Jim Fregosi managed one of the most entertaining and surprising Phillies teams with the 1993 "Wild Bunch." They were a last-to-first team, holding first place from the start of the season to the finish and went all the way to the World Series. However, the years after that magical season were not kind to Fregosi and the Phils, as they experienced three consecutive losing records. When his team finished last in 1996, Fregosi was let go. (George Brace Photo Collection.)

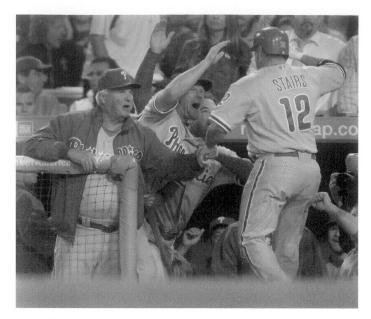

Manager Charlie Manuel congratulates Matt Stairs's seismic swat that beat the Dodgers in Game 4 of the NLCS in 2008, the year Manuel's management style manifested itself with a World Series title. Manuel's quiet but determined leadership is much credited for bringing success to this current talented Phillies team. Known as "Cholly," he is one of the most popular Phillies pilots ever. (Ron Cortes/*Philadelphia Inquirer*.)

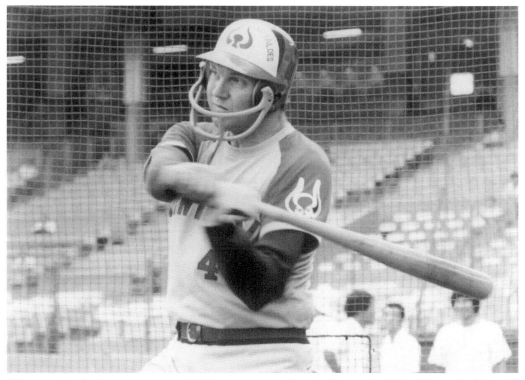

Wearing the helmet is current Phillies manager Charlie Manuel, dubbed "the Red Devil" in Japan. While playing with the Kintetsu Buffaloes of the Japanese Pacific League in 1979, Manuel was hit in the face by a pitch, breaking his jaw. He returned six weeks later, sporting this football-style headgear. Manuel went on to win the Pacific League MVP, batting .324 with 37 home runs and 94 RBI. (Mainchi Image.)

STADIUMS AND FANS

The Phillies have played in palaces and dumps, and two of their palaces became dumps, although this was not the dream first envisioned by founder Al Reach. He designed and oversaw the construction of one of the palaces, the Philadelphia Baseball Park, both versions of which were wonders of stadium construction and fan comfort. But with his passing, inept owners took away the wonder and seemed to care little about the fans. In different ways, this pattern of neglect continued with each stadium.

When the so-called Baker Bowl was abandoned in 1938, few fans were around to say farewell. Shibe Park, a palace when it opened, morphed to shoddy when it closed, and rowdy fans made it more so on closing night. The Vet, first hailed as a palace, had cats living in it to hold down the rodent population when it, too, was abandoned.

That pattern stopped with the advent of Citizens Bank Park.

It could be said that the developers of Citizens Bank Park had W. P. Kinsella's famous words, "If you build it, they will come," in mind when they built "the Bank." Since opening in 2004, the Bank has had capacity crowds filing in to see excellent baseball played by a solid team. Built for comfort, the stadium is hitter-friendly and fan-friendly, featuring plenty of open sight lines to the playing field. There are scads of ballpark food options around the wide concourse, and Ashburn Alley provides concessions, entertainment, and memorabilia in an outdoor area behind center field.

This park is worthy of the vision of quality baseball played in a superior facility as first dreamed of by Al Reach.

This 1883 Phillies scorecard was produced for a game against the Chicago White Stockings. The drawing depicts an artist's conception of the appearance of Recreation Park. As was true of many 19th-century ballparks, it was built on an oddly shaped plot of land with highly irregular outfield dimensions, made of wood, and offered modest seating capacity. The wooden park held around 2,000 spectators, and its borders were city streets, three of them in a square grid. Ridge Avenue, however, cut diagonally across right field, making the foul line 247 feet from home plate. This set the tone for the future right field of the Philadelphia Baseball Park, which eventually became popularized as Baker Bowl. After a terrible start (17-83), the Phillies righted their ship and began playing to capacity crowds. By 1887, they had outgrown this untidy venue and moved to Fifteenth and Huntington Streets. (Bob Warrington.)

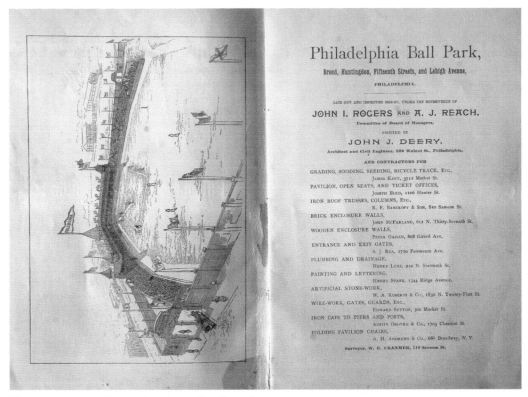

These images are from a brochure distributed by the Phillies to publicize the opening of their new ballpark in 1887. The Philadelphia Baseball Park is considered the first modern ballpark. It offered pavilion seating for customers, exterior walls built entirely of brick instead of wood, and room for horse carriages. A completely rebuilt version after an 1894 fire was the first to feature cantilever construction that reduced the number of supporting posts required to hold up the ballpark's roof. The location was chosen, in part, because of its proximity to passenger railway systems, which was emphasized in the brochure. In addition, the pamphlet promulgates a strict code of fan conduct so that "ladies and gentlemen will be protected from distasteful spectacles of vulgar exhibitions." (Both, Bob Warrington.)

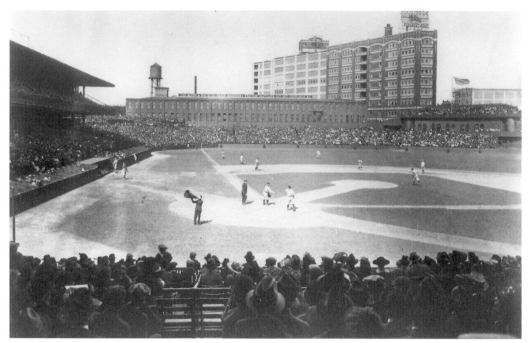

Dubbed Baker Bowl by the 1910s, the ballpark is shown prior to the start of a game. Players seem to be having infield practice, a ritual little performed today. Note the man with the megaphone announcing the battery for both teams. Prior to electric PA systems, the pitchers, catchers, and batters were introduced in this manner. (Joe Hetrick.)

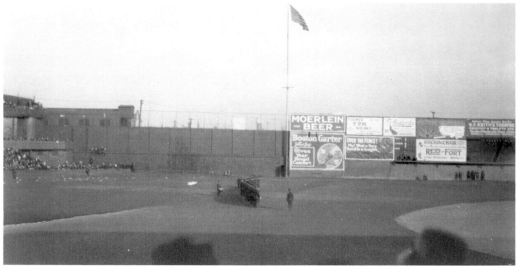

Taken from the stands, this photograph shows the infamous right field wall, which was made of brick and had a wooden top coated with tin—pockmarked by the countless balls that had hit it. Only 280 feet from home, the 40-foot wall was topped with a 20-foot wire-mesh fence. Nevertheless, the wall almost invited home runs to clear it. The Philadelphia police parade can be seen marching across the outfield during an annual widows' and orphans' charity. (Bob Warrington.)

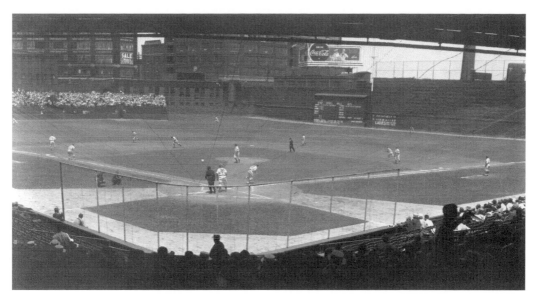

The last game at the Philadelphia Baseball Park (Baker Bowl) featured, fittingly, a laugher. The New York Giants clubbed 19 hits in a 14-1 drubbing that completed a three-game sweep of the hapless Phillies. During 52 seasons at Baker Bowl, the Phillies achieved only one NL pennant, while compiling a composite 3,494-4,026 win-loss record. (TUA.)

Phillies players lounge around before the last game at Baker Bowl in 1938. The clubhouse hints at the shabbiness characterizing the park's condition at the time of the Phils' departure. The two-story clubhouse sat beyond center field and once housed a swimming pool in the basement. No. 6 is George Scharein, a middle infielder, and to his right, donning a shirt, is Morrie Arnovich. (TUA.)

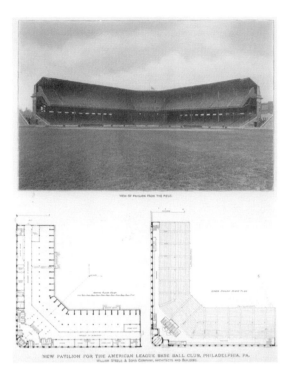

Shibe Park opened in 1909 as the first concrete-and-steel stadium in the country. This photograph and grandstand plan show the initial construction of the stadium that sat 20,000 (eventually expanded to 33,000). Home of the Philadelphia A's, the Phillies joined them in 1938. Renamed Connie Mack Stadium in 1953, the Phillies played there until they moved to Veterans Stadium in 1970. (FLP.)

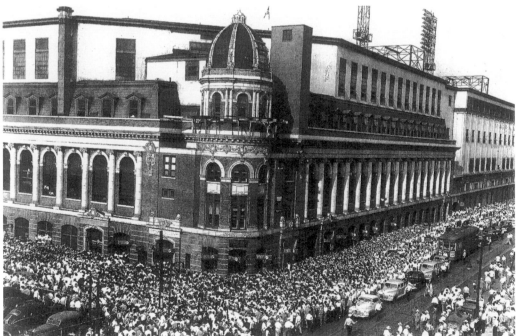

Shown here in 1948, the French Renaissance–style Shibe Park thrilled millions of fans during its existence. The entrance foyer featured an electric chandelier, marble steps, and polished granite walls. The steps led to a concourse lined with food concessions and ramps to the seats. The stadium, however, lost its luster over the years, and when it eventually closed, its time had passed. (PAHS.)

To commemorate the closing of Connie Mack Stadium in September 1970, this Phillies trio wears gear reminiscent of the 1909 era when the stadium opened. Ticket takers and ushers wore similar garb that evening. Sporting the derby hats and handlebar mustaches are, from left to right, players Tim McCarver and Joe Hoerner and coach George Myatt. The Phillies planned an elaborate closing ceremony, which included a helicopter landing on the infield and taking home plate to the new Veterans Stadium. Unfortunately, a capacity crowd overwhelmed the team's staff, began plundering early, and took over the stadium when the winning run crossed the plate. Now a mob, the fans swarmed onto the playing field and proceeded to deconstruct Connie Mack Stadium. They ripped out seats, tore up the turf, stole the bases, stripped off pieces of the scoreboard, and generally took anything they could get their hands on, including the urinals. The helicopter arrived, hovered over the raging mob for 20 minutes, and then gave up. Souvenirs of that evening can be found in hundreds of homes throughout the Delaware Valley. (TUA.)

These two photographs represent proposed stadiums to replace Connie Mack Stadium. Seen above is a proposal that promised to transform the Pennsylvania Railroad track yards at Thirtieth Street Station. Architect Vincent Kling points out to Mayor James Tate (center) a round stadium as the centerpiece of a development that would have brought beauty to an ugly landscape. The extensive tracks would be completely covered by the development, but the huge cost proved impractical for the times. Below is the model of a majestic baseball stadium similar in design to the eventual Citizens Bank Park. Had it been built, it would have been a Camden Yards before Camden Yards became synonymous with beautiful ballparks. The proposed site at the corner of Broad Street and Pattison Avenue would be the eventual placement for the new stadium. (FLP.)

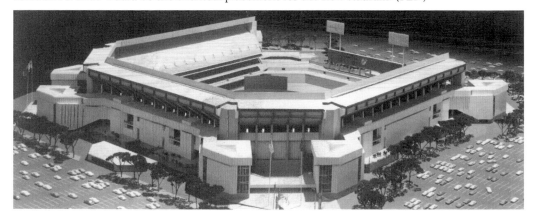

STADIUMS AND FANS

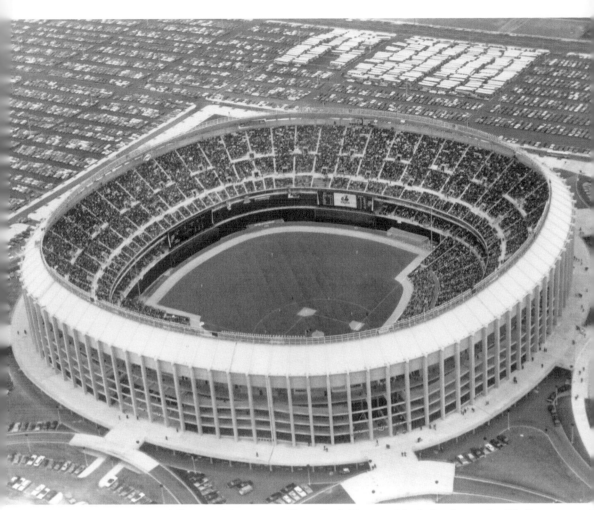

After the 1970 season, following 33 years at Shibe Park/Connie Mack Stadium, the Phillies finally moved to a new stadium in South Philadelphia. Billed as an all-purpose (baseball/football) stadium, it was quickly discovered by both the Phillies and the NFL Eagles that it was not suitable for either. Known as Veterans Stadium (nicknamed "the Vet"), this new park became the Phillies' home turf for another 33 years, until Citizens Bank Park was opened in 2004. The Phillies' success was unpredictable while at the Vet, with prosperous runs interspersed amidst some very bad seasons. Still, the Vet was the park where the Phillies enjoyed one of their most thrilling seasons in 1980, when the franchise finally reached the pinnacle of success and won their first World Series. Not so successful were two other World Series appearance in 1983 and 1993. (NBHF.)

Showing form that might have landed him a tryout with the Phillies' pitching staff, a local worker practices his windup during construction of the future pitcher's mound at Veterans Stadium. Taking a break from his duties, the worker seems poised to record a "K" on someone's scorecard. (FLP.)

A beer vendor shows his wares on the first Sunday that beer was allowed to be sold at a ballpark in Pennsylvania. The state's blue laws prohibited many an activity on Sunday. These laws even restricted playing times on Sundays. During the second game of a doubleheader, no new inning could begin after 6:00 p.m. EST (7:00 p.m. EDT). Such games were suspended and continued at another convenient time. (FLP.)

Created by artist Joe Brown, this is one of four athletically themed statues that were placed around the perimeter of the Vet during the 1970s. *Play at Second* is located on Pattison Avenue in front of the former site of the Vet. It depicts one of baseball's exciting plays, an infielder poised to tag a sliding runner. (Photograph by Seamus Kearney.)

Joe Brown is a Philadelphia native and graduate of Temple University. Another of his baseball-themed statues, *The Hitter* shows a successful batting effort with a strong follow-through on his swing. This creation is situated on an access road behind the Vet's old site. (Photograph by Seamus Kearney.)

THE PHILADELPHIA PHILLIES

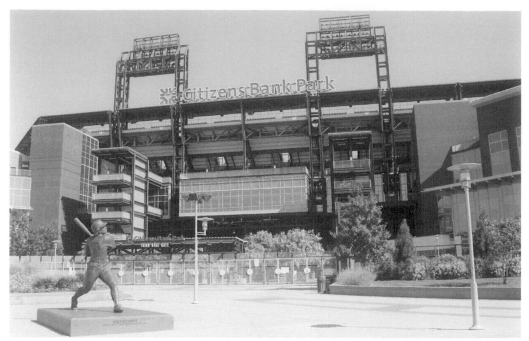

The Vet suited neither the Phillies nor the Eagles, but neither team could afford building another, so the teams stayed for three decades. As time passed, however, movement to build anew grew. The city could not afford funding and hopes died until the Pennsylvania State Legislature agreed to include Philadelphia for funding of stadiums originally limited to Pittsburgh in 2001. The Phillies desired a center-city location, but various proposals could not be reconciled, so they settled for a site next to the Vet. Shown above, Citizens Bank Park, which opened in 2004, enjoyed immediate success. Wide concourses, great sight lines, and a cozy playing field made for fan comfort and excitement in what is considered a "hitters park." The photograph below exhibits the great sight lines in a view from the right field concourse. (Both photographs by Seamus Kearney.)

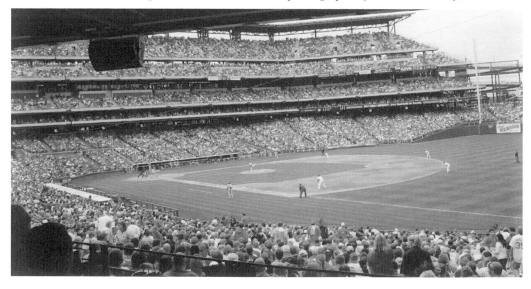

STADIUMS AND FANS

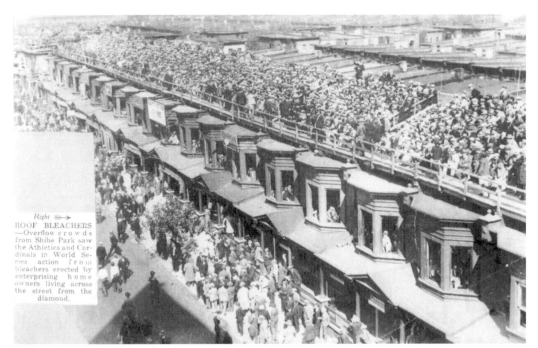

Rooftop seats on the houses on Twentieth Street across from Shibe Park became a landmark of Philadelphia baseball. From 1910, when the Athletics played their first World Series, until 1934, when Connie Mack built a 30-foot wall, hundreds of fans watched games there and avoided paying the Athletics. By the late 1920s, there were as many as 2,000 fans in those seats. By 1934, the Depression cut more deeply into Mack's profits, so he erected a wall blocking the view. The neighbors sued Mack for blocking their view, but they lost the case. Shown below are the "rooftop bleachers" at Citizens Bank Park. They serve to commemorate the original rooftops opposite Shibe Park. (Above, LOC; below, photograph by Seamus Kearney.)

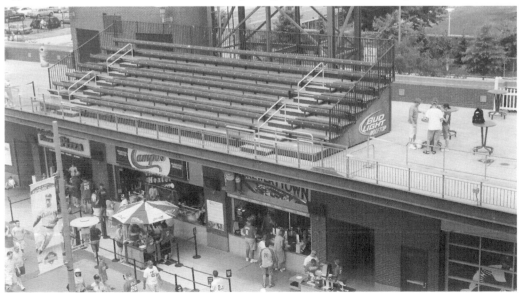

THE PHILADELPHIA PHILLIES

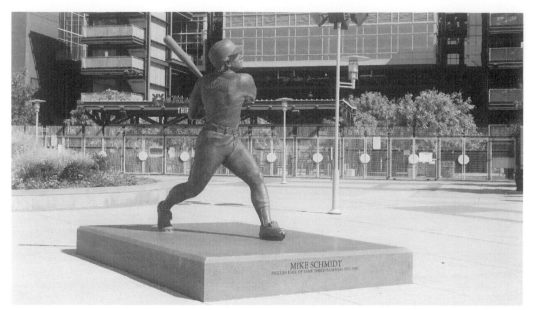

Created by artist Zenos Frudakis, this larger-than-life version of Mike Schmidt, the Phillies' best third baseman, appropriately graces the third-base gate to Citizens Bank Park. Part of a trio of statues of recent Phillies standouts (Mike Schmidt, Steve Carlton, and Robin Roberts), the Schmidt statue welcomes the millions of fans who flock to the new stadium each year to support their successful baseball team. (Photograph by Seamus Kearney.)

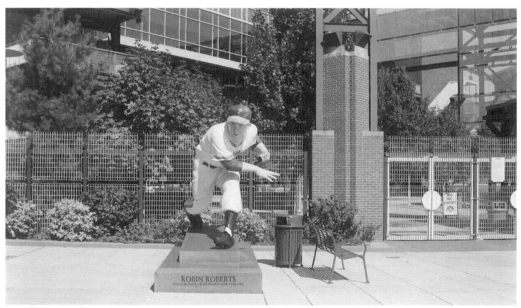

Another Frudakis creation, this statue of the Whiz Kids' mound stalwart, Robin Roberts, stands beside the ticket windows of Citizens Bank Park by the first-base gate. It is a favorite hangout for folks who congregate before the game. Almost always, there are people who line up at the statue to have their picture taken by friends and relatives. (Photograph by Seamus Kearney.)

STADIUMS AND FANS

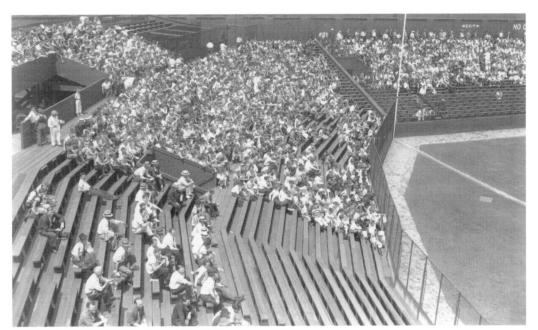

This photograph was taken during the last game the Phillies played at Baker Bowl on June 30, 1938. Playing in front of a crowd of about 1,500, they were overwhelmed by the New York Giants 14-1. Note that the empty seats are the more expensive sections. After a short road trip, the Phillies returned to their new home field at Shibe Park, home of the Philadelphia Athletics. (TUA.)

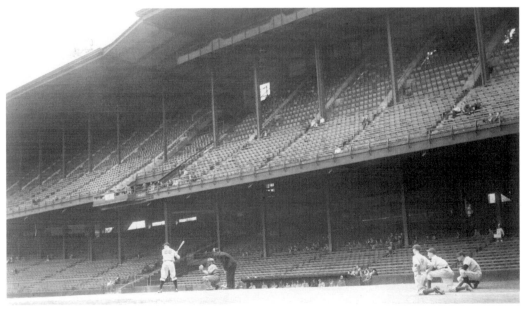

From 1938 to 1945, the Phillies finished last seven times and had eight consecutive losing seasons. This image shows just how many people would show up at Shibe Park to see this horrid display. Reportedly, Phillies hurler Kirby Higbe opined of this era's fans, "At times they were afraid to boo us because we outnumbered them." (NBHF.)

On October 1, 1950, Phillies fans gathered at the Pennsylvania Railroad's Thirtieth Street Station to welcome the triumphant Phillies home from their final game victory over the Brooklyn Dodgers. Dick Sisler's three-run homer in the 10th inning, combined with Richie Ashburn's throw to cut down Cal Abrams at home in the ninth and Robin Roberts' five-hit, 10-inning pitching masterpiece, gave the Phils their first NL pennant in 35 years. (TUA.)

In an age without electronic scoreboard animation to encourage fans to make noise and cheer more loudly, some Phillies fans were forced to bring in their own noisemakers. This man, perhaps emulating Tommy Dorsey, tries to encourage the Phillies to rally in a 1965 game. (TUA.)

Patrons at a local tavern lift their glasses high in tribute to the 1964 Phillies. Air-conditioned taverns throughout the Philadelphia area featured Phils games on television during the hot summer months of the 1960s. (TUA.)

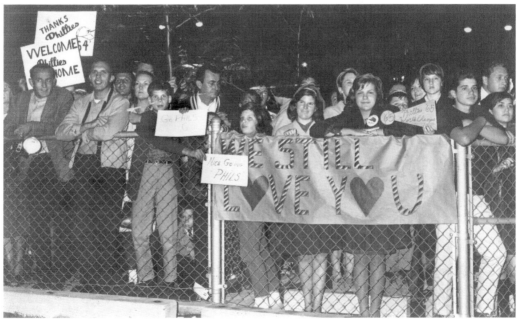

Despite their bitter disappointment, loyal fans crowd in at the airport to welcome the 1964 Phillies back home from Cincinnati. The Phils had won the last two games of the season after losing 10 games in a row and led the National League race by 6.5 games with 12 left to play, but finished one game behind the St. Louis Cardinals. (TUA.)

THE PHILADELPHIA PHILLIES

Longtime Phillies fan Harry Schifren, known as "Yo-Yo," takes in a game at the Vet during the 1970s. Homeless, he hung out at Palestra basketball games and shot fouls during time-outs. When he started coming to the Vet to see the Phils, team president Bill Giles befriended Yo-Yo and presented him with a lifetime pass to see the team. A statue of him resides in the Baseball Hall of Fame. (TUA.)

To encourage the Phillies to play at a higher level, fans at the Vet tootle gracefully on their kazoos under the direction of noted bandleader Fred Waring. The Pennsylvanians, Waring's choral and rhythm group, played on the world's stage for six decades. (TUA.)

STADIUMS AND FANS

6

ODDITIES, EPHEMERA,

AND FUNNY STORIES

During the course of the Phillies' history and that of the stadiums in which they played, there have been a number of notable happenings and circumstances. Among them are baseball firsts, crazy occurrences, celebrations, and just plain newsworthy items.

Among the Phillies' firsts are building the first cantilevered stadium (the Philadelphia Baseball Grounds), playing in the first official game (against the Brooklyn Superbas) held at Ebbetts Field in 1913, competing in the first night game in major-league history (against the Cincinnati Reds), and having the first sitting president to not only attend, but also toss out a ball during a World Series.

Crazy occurrences involve a riot at the old Baker Bowl, the deconstruction of Connie Mack Stadium during and after its last game, the daily shenanigans of Major League Baseball's most recognizable mascot, and Roy Sievers's futile slide

The Phillies celebrated their Golden Jubilee in 1933 at Baker Bowl, held reunions of the Whiz Kids at the Vet in 1960 and 1975, hosted the World Series in four of their five playing fields, and—well, Phils fans are still celebrating 2008.

One especially newsworthy item was the 1945 "Catch of Death," an event of the "Sports-Go-Bang" promotion used to sell war bonds during World War II, which netted $5 million for the war effort through the help of the 30,000 fans at Shibe Park. Another is Annie Oakley's sharpshooting display during spring training in 1923.

In the following pages are accounts of stories that not only recall the product on the field, but also the happenings off the field.

However, before relating these stories, there is a somewhat sobering account of what war has exacted on some of the players. Eddie Grant died in World War I. Grover Cleveland Alexander left Philadelphia (went to war and was traded by Baker) and came back with an affliction that would haunt him the rest of his life. "Losing Pitcher" Mulcahy did not lose his life, but his fastball. And, alas, Curt Simmons could have made a difference in the Whiz Kid's World Series—if the Phillies had done the right thing.

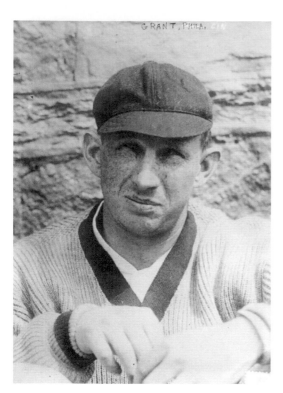

Eddie Grant is one of three major leaguers killed during World War I. Eddie played four seasons at third for the Phillies and led NL third basemen in putouts in 1909. Harvard educated, he preferred reading books on the train during road trips. In 1909, he graduated from Harvard Law School and practiced in Boston during baseball's off-season. Captain Grant succumbed to shell fire during the Meuse-Argonne offensive in 1918. (LOC.)

Attired in his Doughboy uniform, Grover Cleveland Alexander goes off to France during what was then called The Great War. Phillies owner William Baker traded Alexander and battery mate Bill Killefer to the Cubs because he thought the war would not end soon, and he decided to get what he could for them. Losing Alexander and Killefer began the Phillies' descent into the Dark Ages. Alexander may have had a dormant epileptic condition that was exacerbated by poisonous gas inhalation during the war. (NBHF.)

ODDITIES, EPHEMERA, AND FUNNY STORIES

Hugh Mulcahy became the first major-league player drafted into the army in March 1941. He lost four full seasons because of World War II, spending those years on camp ball teams, usually pitching for charity or war bond drives. Above, he is shown in a Giants uniform signing autographs to raise money for war bonds. (TUA.)

Sgt. Hugh Mulcahy (left), former major-league pitcher for the Phillies, participates in a coin toss before a service game "somewhere in Tennessee," according to the back of the image, during World War II. Former Reds player Sgt. Joe Gee (right) awaits the outcome. Known as "Losing Pitcher" while with the perennial last-place Phils, Mulcahy, true to his nickname, lost this army game, too. (NBHF.)

THE PHILADELPHIA PHILLIES

World War II interrupted pitcher Schoolboy Rowe's tenure with the Phillies in 1944 and 1945, but not before his hitting prowess let him lead all NL pinch hitters in 1943. His navy service included play on the naval base's ball teams. Out of the service in 1946, he played four more seasons for the Phils, winning 39 games. In 1947, he made a pinch-hit appearance for the National League in the All-Star Game. (NBHF.)

Curt Simmons greets fans at the 1950 World Series. He could not play in the game because the army activated him that August. Simmons's absence contributed to the team's swoon, which did not rebound until Dick Sisler's home run in the season's last game put them into the Series. Although granted leave for October, the Phils suited him up but chose not to request that Commissioner A. B. "Happy" Chandler put him on the Series roster. (TUA.)

ODDITIES, EPHEMERA, AND FUNNY STORIES

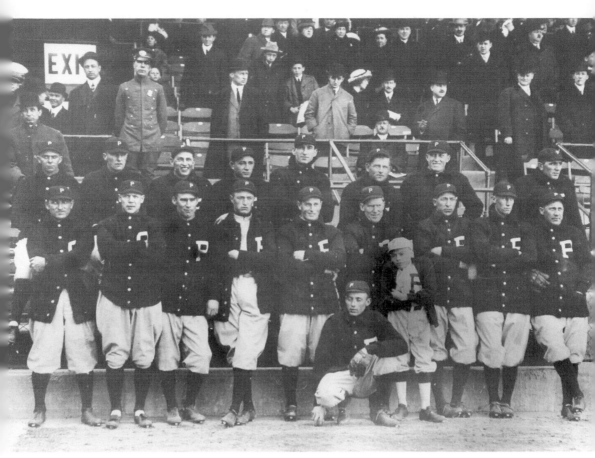

This photograph, taken at the inaugural opening day at Ebbets Field in Brooklyn, shows another first for the Phillies. Players and fans are dressed in their warm clothing, as April 9, 1913, proved to be a very cold day. To appropriately inaugurate its new ballpark, Brooklyn was allowed to open its season a day before every other team in the major leagues. The Phillies, with a reduced squad, traveled to Brooklyn for this historic single-game occasion. The regular position players were all present, but only some pitchers (Tom Seaton, Ad Brennan, and Erskine Mayer) would make the journey. This shortened roster gave the pitchers an extra day of rest, but, equally importantly, it saved the team expenses for meals, lodging, and transportation. The Phillies won the game 1-0, scoring an unearned run in the first inning. Pitcher Tom Seaton shutout the Superbas and catcher/manager Red Dooin cut down three would-be base stealers at second. Following this game, both teams boarded trains to Philadelphia, where they would complete the four-game series. (Bob Warrington.)

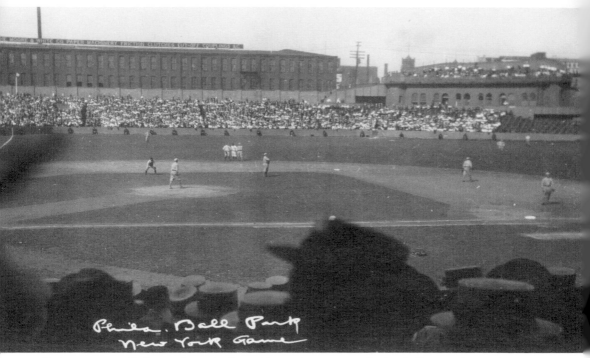

Phila. Ball Park
New York Game

With tempers still flaring from the June 30, 1913, game in which Phillies pitcher Ad Brennan punched John McGraw after being taunted by the Giants manager, the Giants returned to Philadelphia for an August 30 game. There was much anticipation, as this photograph taken before the game shows. Note McGraw near second base and Christy Mathewson on the mound. After eight innings of play, with the Phils up 8-6, a Giant player complained that the white shirts of fans sitting in the center field stands were affecting his ability to hit. The umpire tried to have the fans removed, and when it proved impossible, he suspended the game, which was completed on October 2. The fans were annoyed and stalked McGraw and the Giant players to the North Philadelphia train station, which was a few blocks away. McGraw escaped and left his players to fend for themselves. (Bob Warrington.)

This illustration features Rube Waddell posed between the 1915 schedules of the two Philadelphia ball clubs. Former Philadelphia Athletics pitcher Waddell had died the previous year of tuberculosis. The two clubs' fortunes did not mesh in 1915; the A's, weakened by Mack's sales of his regulars, finished last in the American League, with 109 defeats, while the Phillies, bolstered by Alexander's 31 wins, went to their first World Series. (LOC.)

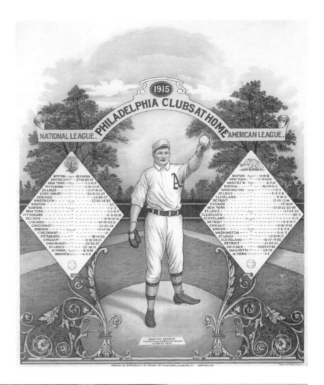

This 1923 Phillies spring training photograph was taken in Leesburg, Florida. The team was nothing special, finishing last in the National League; however, it was reported that sharpshooter Annie Oakley had stopped by for a demonstration of her shooting skills. Oakley threw pennies into the air and shot them as they fell. Phillies ran to find themselves souvenirs after the display. Notice the hodgepodge of uniforms, many of them from the 1921 and 1922 seasons. (Bob Warrington.)

This formal event marked Phillies slugger Lefty O'Doul's (second from left) second trip to Japan to encourage interest in baseball. Pictured are, from left to right, Herb Hunter (trip organizer), O'Doul, Ted Lyons (Hall of Fame pitcher), and Moe Berg (AL catcher and purported spy). O'Doul remained in Japan for nearly three months to help train Japanese ballplayers. Still recognized as the great mentor of Japanese baseball, O'Doul was elected to the Japanese baseball Hall of Fame in 2002. (NBHF.)

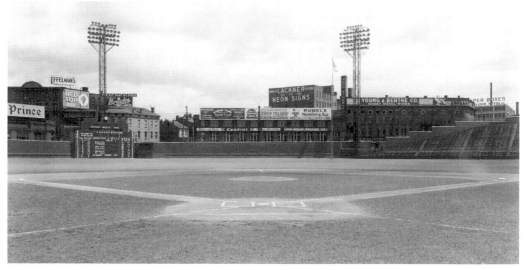

This is not a Philadelphia ballpark but is significant because it is here, at Cincinnati's Crosley Field, that the Phillies captured another first in their history—the first night game in the major leagues. The Phillies lost to the Reds 2-1 before a crowd of 20,000 in a game that lasted just an hour and a half but ushered in the certainty of night baseball throughout the future major leagues. (NBHF.)

ODDITIES, EPHEMERA, AND FUNNY STORIES

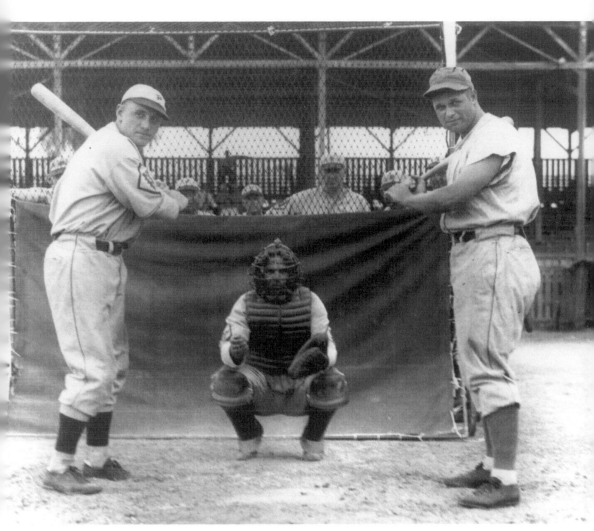

Batting a Triple Crown (leader in home runs, batting average, and RBI) has only occurred 14 times in modern baseball history. However, 1933 was a big year for Philadelphia baseball when two of its favorite sons won the Triple Crown in their respective leagues. Jimmie Foxx (right) won the AL crown with a .356 average, 48 home runs, and 163 RBI, while Chuck Klein of the Phillies won the NL honor with a .368 average, 28 home runs, and 120 RBI. A year earlier, both players had been named MVP in their respective leagues. Klein was selected to the NL All-Star Team in 1933 and 1934. Although both heavyweight stars are Hall of Famers, Foxx outshined Klein with nine consecutive all-star selections, two World Series rings, and three MVPs. (NBHF.)

IT'S OVER YOUR HEAD

This document is the front and back cover of an 1886 Phillies scorecard. Scorecards from this era often had comical caricatures of baseball players shown on the front covers. The back cover was intended for paid advertising, but the Phillies were having a hard time attracting any at the time. (Bob Warrington.)

This is the program from the 1933 Golden Anniversary of the Phillies. The team celebrated this event with an old-timers game. Prior to the game, former players were treated royally with a formal reception at the Bellevue-Stratford Hotel. Following this gala, everyone was transported from the hotel in an ornate carriage three miles up Broad Street to Baker Bowl for the game. (Bob Warrington.)

These ticket stubs are actually rain checks. Frequently, in the old days, if a game was called because of rain, the holder could present the stub (marked for the specific game he or she attended) and be admitted to any other game during that season. Nowadays, with long rain delays prolonging the games, the number of rainouts is considerably smaller. (Bob Warrington.)

To celebrate the Golden Anniversary of the National League in 1925, the Phillies presented season ticket holders (there were not many), front office personnel, and distinguished personages (including Commissioner Kennesaw Mountain Landis) with these handsome watch fobs. They were inscribed to the recipient on the back along with a notation of the Golden Anniversary. The design, from the 1915 Phillies World Series press pin, depicts Philadelphia founder William Penn pitching from atop his perch on City Hall. (Bob Warrington.)

Scorecards were a revenue-producing enhancement for baseball teams. This 1927 scorecard displays the Phillies' schedule and advertising (note the one for Spaulding Sporting Goods). The scorecard also features the Phillies' logo with William Penn. Fans would purchase them for a nickel and use them to score the game. Today it is rare to see someone in the stands scoring the game, although management still sells the scorecards at Citizens Bank Park. (Bob Warrington.)

The back of the scorecard (right) highlights a number of hotels situated in the cities of the 1927 National League. Phillies management accepted advertising from the hoteliers in hope of attracting fans who were following the team abroad. Today Phillies fans show up by the hundreds at their away games, especially in Baltimore (during interleague play) and Washington, D.C. (Bob Warrington.)

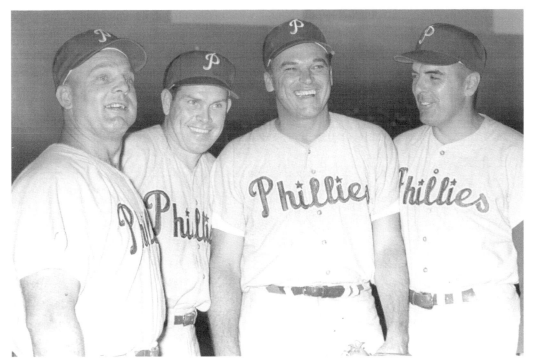

This is a reunion of the Whiz Kids in 1960. Robin Roberts and Curt Simmons were still pitching for the Phillies. Dick Sisler was out of baseball, and Andy Seminick had retired after two final seasons with the Phillies in the late 1950s. The Phillies also honored the Whiz Kids with a 25th reunion held at the Vet in 1975. (TUA.)

A major part of the construction materials at Baker Bowl was brick, particularly the notorious right-field wall. In 1950, the wall was demolished after it had collapsed in a wind storm. Bob Jackson, an official of the demolition company and ardent Phillies fan, was given this painted brick as a gift by the wrecking crew. Now it has become a ritual for baseball teams to offer souvenirs and memorabilia from stadiums that have been razed. (Bob Warrington.)

Hall of Fame pitcher Eppa Rixey is seen picking fruit in Florida. During spring training in these years, players' lunches were terrible. Usually sent over by the hotel, they consisted of fried fish that often had the heads still attached and were cold from the transport to the ballpark. To supplement these inadequate meals, players would often help themselves to oranges in nearby groves, much to the chagrin of the owners of the orchards. (Bob Warrington.)

Sylvester Johnson was an average pitcher who spent 19 years in the major leagues. Perhaps his most famous outing as a Phillie was against the Boston Braves at Baker Bowl on May 29, 1935. In that game, Johnson struck out Babe Ruth for the last time in the slugger's career. In fact, Johnson caused the Babe to go down swinging twice in that game. The following day, Ruth walked off the field after a single at-bat and announced his retirement. (NBHF.)

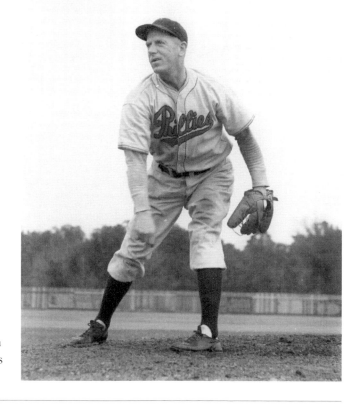

COVALESKI, PHILA. NAT'L

Harry Coveleski earned the title "Giant Killer" as a Phillies rookie when he beat John McGraw's Giants three times in five days in September 1908. Had the Giants won any one of those games, they would have gone to the World Series. McGraw was determined that Coveleski would never beat him again. He investigated Coveleski's idiosyncrasies, which included his habit of carrying a sausage in his back pocket. Every so often, Coveleski would surreptitiously take a bite and return it to his pocket. McGraw and the Giants taunted Coveleski with catcalls and imitations of his munching on the sausage. It was also discovered that Coveleski, as a drummer in his hometown band, had lost his fiancé to the trumpet player. McGraw went so far as to hire a brass band when the Phillies were in New York in order to harass Coveleski. The pitcher was sufficiently bothered and was unable to pitch effectively for several years. Returning to the major leagues in 1914, he proceeded to win 65 games over a three-year period with Detroit. (LOC.)

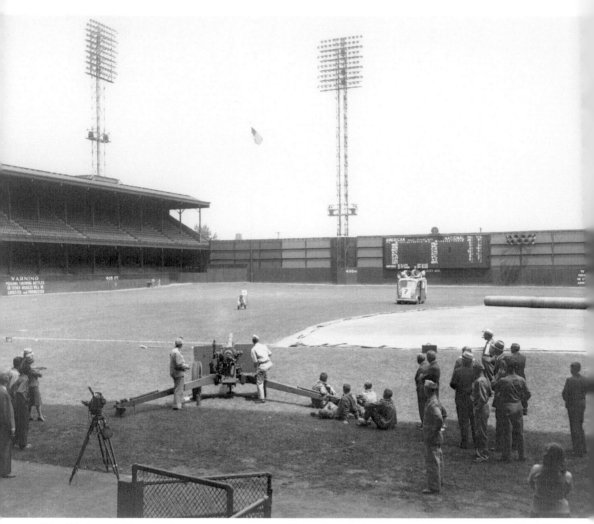

The Phils and A's agreed to a promotion to sell war bonds during World War II. Before 30,000 at Shibe Park in 1945, the event netted $5 million for the war effort. Local lad Bill Taylor was recruited to catch a baseball fired by a .75-mm cannon placed along the third baseline, 125 feet away. A father of two, Taylor accepted the job only after getting assurances that he could use a different name so as not to alarm his wife. He may have been alarmed himself when a practice shot, primed with too much charge, whizzed past him and went through the scoreboard. Nevertheless, Ian Brokaw (Taylor's assumed name), also called "the Fearless One," positioned himself in center field for the Catch of Death event during the Sports-Go-Bang promotion. He received a standing ovation for the feat when he successfully caught the baseball. Taylor provided the following description of the experience: "There was no spin on the ball as it came to me. It wiggled, sort of like a knuckler, but its velocity made it a super-fastball. I mean, it *moved!*" (TUA.)

This photograph shows the Phillies broadcast team of Andy Musser (left), Rich Ashburn (center), and Harry Kalas during the 1970s. Kalas came to the Phillies from Houston in 1971 to join Ashburn, who arrived in 1963 and had been teaming up with Bill Campbell, a veteran Philadelphia sports announcer. Ashburn, a Hall of Fame center fielder from the Phillies, remained in the booth until his death in 1997. In 1976, Phillies Hall of Fame pitcher Robin Roberts joined the group, as did Musser. Roberts, however, remained only one year, while Musser stayed on for 23. In 2002, Kalas won the coveted Ford Frick Award for excellence in baseball broadcasting. He continued broadcasting until his death in 2009. In 1976, Chris Wheeler, who is still active, joined the group and remains a part of the television crew. (TUA.)

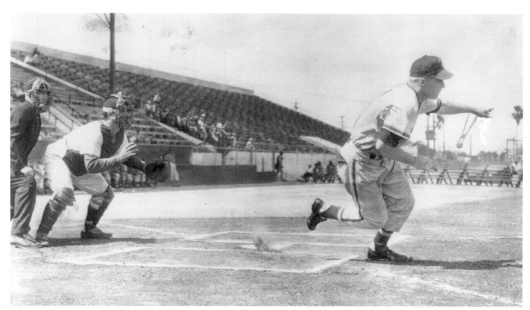

Richie Ashburn is seen here laying down his patented drag bunt into the area known as Ashburn's Alley (a name that is now memorialized as a section of Citizen's Bank Park). Ashburn carried a .305 lifetime batting average and won the NL batting titles in both 1955 and 1958. He was a five-time all-star and was elected to the Hall of Fame in 1995. (TUA.)

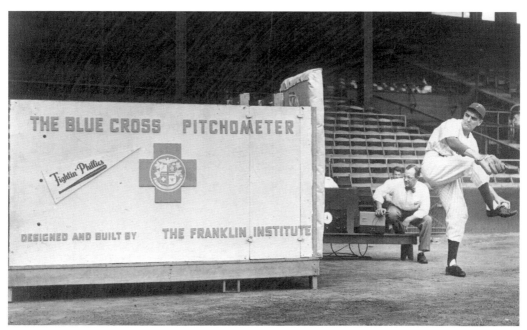

Phillies southpaw Curt Simmons is throwing a ball into the "Pitchometer" to measure its speed. This demonstration, sponsored by the Franklin Institute (a local science museum) and Blue Cross, allowed fans attending the game to try their pitching skills. This 1950 device is a far cry from the modern, compact radar guns that clock current pitching speeds from the stands. (TUA.)

A versatile utility man, Cookie Rojas is one of the few players in the major leagues to have played every position during his career. He became a fan favorite during his time in Philadelphia (1963–1969) and made the 1965 All-Star Team. In regard to the 10-game losing streak in 1964, he said, "It was like swimming in a long, long lake—and then you drown." (NBHF.)

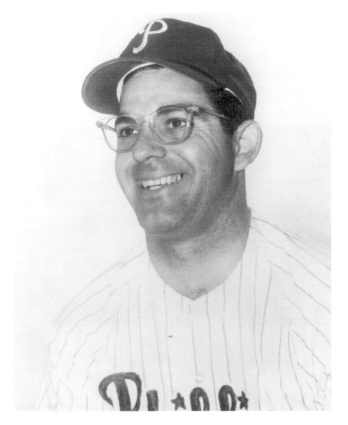

On August 17, 1975, the Phillies welcomed back the players from the 1950 World Series team. The Whiz Kids played an old-timers exhibition, while the fans had an opportunity to see their boyhood heroes return in Phillies uniforms. As this photograph was snapped, former catcher Andy Seminick was being cheered. (*Philadelphia Inquirer.*)

Two iconic figures in 1970s baseball jive each other at the Vet. The Phanatic, the official mascot of the Phillies, first appeared at the Vet in 1978 to attract more families to the Phillies games. Spurred by the existence of the San Diego Chicken, the Phillies decided to have a mascot of their own. Harrison/Erickson of New York, who helped create Jim Henson's Muppets, came up with the Phillie Phanatic. The name commemorates the fanaticism of the Phillies fan base, and the mascot became an immediate success. The Phanatic appears before, during, and after games with on-field stunts, firing hot dogs and T-shirts into the stands, as well as taunts of the opposing team and, sometimes, the umpires. Pres. Bill Giles once wrote that not initially copyrighting the costume was one of his worst mistakes—it cost him $250,000. The Phanatic continues to delight Phillies fans to this day. He led the World Series Victory Parade down Broad Street to the Citizens Bank Park in 2008. (TUA.)

This photograph depicts the World Series that never was. A Phillies staffer displays the stacks of World Series tickets for the Phillies near the end of the 1964 season. Because of the tight race among the National League's four contenders, each team was allowed to print tickets. The Phillies later made them available as souvenirs when the team could not clinch the pennant. (TUA.)

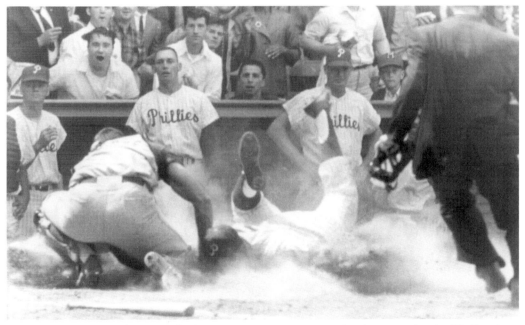

"In a cloud of dust and a hearty hi-ho Sievers," Roy Sievers, a first baseman for the Phillies (not the swiftest man on the field), is tagged out trying to stretch a triple into an inside-the-park home run against the Reds in May 1964. Phillies players behind the play are, from left to right, Jim Bunning, Bobby Wine, and Don Hoak. The Cincinnati catcher is Johnny Edwards. Phils lost the game 2-0. (TUA.)

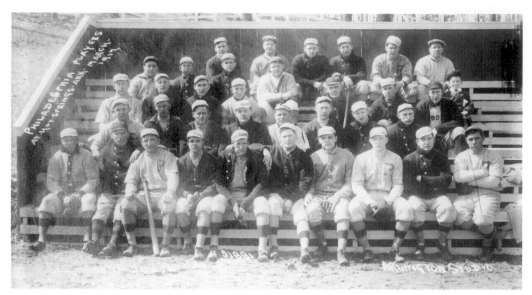

The 1912 Phillies team poses at Fogel Field during spring training in Hot Springs, Arkansas. Other major-league teams at Hot Springs included the Brooklyn Dodgers, Pittsburgh Pirates, and Boston Red Sox. The Phillies finished fifth during player/manager Red Dooin's first season. Major producers included Gavvy Cravath (11 home runs, third in the league) and Grover Cleveland Alexander (19 wins, leading the league in innings pitched and strikeouts). (LOC.)

On a billboard in Stirling, Scotland, advertisers miss the mark in invoking the use of Len Dykstra's glove to sell shoes. During his career with the Phillies, Dykstra was an all-star three times and finished second to Barry Bonds in the MVP voting in 1993. (*Philadelphia Inquirer*.)

A graduate of the University of Pennsylvania in Philadelphia, Walt Masters was a two-sport athlete who had a rather short career in Major League Baseball, spending one year each with the Washington Senators (1931), the Phillies (1937), and the Philadelphia Athletics (1939) as a rather ineffective pitcher. He combined this with an equally short career in the National Football League, spending one year with the Philadelphia Eagles (1936) and two years with the Chicago Cardinals (1943 and 1944). In 1943, as a passer, he threw two touchdown passes, one of them against the Eagles. He was also a punter and kick returner in 1943. His longest punt was 49 yards. (Both, George Brace Photo Collection.)

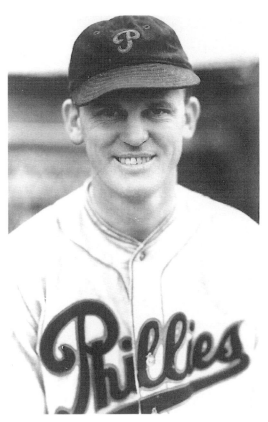

In this photograph, Casey Stengel sports a uniform bearing the names of all the teams whose uniforms he wore during his 54-year career. Stengel, an icon of baseball, played in the National League for 14 years and managed for 25 more (13 in the NL, 12 in the AL). He began with the Dodgers and then went on to play for the Giants, Pirates, Braves, and Phillies. Stengel was also known for his on-field antics, which included having a sparrow fly from under his cap when he removed the hat. In 14 years in the majors, Casey held a lifetime .284 batting average. He went on to a Hall of Fame career as a manager of the Dodgers, Braves, Yankees, and Mets. With the Yankees, he won 10 pennants and seven World Series titles. He was elected to the Hall of Fame in 1966. Seen above, he poses a few weeks before his death. (Photograph by Robert Kaufman, used with permission.)

ODDITIES, EPHEMERA, AND FUNNY STORIES

ABOUT THE SOCIETY
FOR AMERICAN
BASEBALL RESEARCH

The Society for American Baseball Research (SABR) was established in Cooperstown, New York, in August 1971. Its mission is to foster the study of baseball, past and present, and to provide an outlet for educational, historical, and research information about the game.

SABR carries out its mission through programs that encourage the study of baseball, past and present, as a significant athletic and social institution; encourage further research and literary efforts to establish and maintain the accurate historical record of baseball; encourage the preservation of baseball research materials; and encourage the dissemination of educational, historical, and research to inform the nation about baseball.

The organization has more than 50 regional chapters in the United States, Puerto Rico, Canada, the United Kingdom, and Japan. The Connie Mack chapter, housed in Philadelphia, has a membership of about 400. It meets every summer (often at Citizens Bank Park) to exchange information via oral presentations, panels of experts, and the viewing of new films. During the winter months, members gather at a local venue for a "hot stove" meeting to maintain the ties so often lost during the cold season.

For more information on SABR and membership, visit www.sabr.org or call 800-969-7227.

Discover Thousands of Local History Books
Featuring Millions of Vintage Images

Arcadia Publishing, the leading local history publisher in the United States, is committed to making history accessible and meaningful through publishing books that celebrate and preserve the heritage of America's people and places.

Find more books like this at
www.arcadiapublishing.com

Search for your hometown history, your old stomping grounds, and even your favorite sports team.